Postcard History Series

Clinton County

ON THE COVER: Dedicated on November 13, 1930, the new stone arch bridge that forms part of Plattsburgh's Bridge Street firmly connected the eastern and western sides of the street. With sidewalks, stairs leading to the river below, and an unobstructed thoroughfare, the bridge was lauded as a success. Some 3,000 people attended the opening ceremonies, according to *The Plattsburgh Sentinel*. (Courtesy Clinton County Historian's Office.)

ON THE BACK COVER: The first building at the Catholic Summer School in Cliff Haven, the Champlain Club served as an administrative building and was erected at a cost of $25,000. (Courtesy Clinton County Historian's Office.)

Postcard History Series

Clinton County

Anastasia L. Pratt

Copyright © 2014 by Anastasia L. Pratt
ISBN 978-1-4671-2110-1

Published by Arcadia Publishing
Charleston, South Carolina

Printed in the United States of America

Library of Congress Control Number: 2013946004

For all general information contact Arcadia Publishing at:
Telephone 843-853-2070
Fax 843-853-0044
E-mail sales@arcadiapublishing.com
For customer service and orders:
Toll-Free 1-888-313-2665

Visit us on the Internet at www.arcadiapublishing.com

Dedicated with love to Lottie (Cantwell) Toplitsky and the late Arnold Toplitsky, who have always acted like devoted grandparents. And in loving memory of my grandparents, Adelard and Rita (Therriault) Cusson and Harold and Viola (Cantwell) Pratt.

Contents

Acknowledgments		6
Introduction		7
1.	Route 9	9
2.	Around Town	27
3.	A Trip to the City	53
4.	At the Base	71
5.	Where to Stay?	85
6.	On the Waterfront	101
Bibliography		126
Index		127

Acknowledgments

I am blessed by wonderful family and friends, near and far, who support my work. Thank you all. I am especially grateful to those who patiently answered my questions (Jason Borrie, Bob Cheeseman, Tim Clukey, Julie Dowd, Priscilla Hammond, Kelly Julian Sexton, and Ruth Starke), who shared their postcards (Felicia Barcomb and the family of Ron Venne; Elizabeth Botten; Bob Cheeseman and the town of Chazy Historian's Office; Dick Lynch; Amanda Palmer, Shaun Heffernan, and the Alice T. Miner Colonial Museum; Melissa Peck and the Clinton County Historical Association; Kelly Julian Sexton and the Cole Collection, Plattsburgh Public Library; Mary Starke; Gary Wells; and Darlene Winterkorn), and helped scan images (Tim Clukey, Nicole Pratt Coskey, and Gloria Cusson Pratt). Finally, thanks to my parents, Jim and Gloria Pratt, who taught me that with hard work, anything is possible, and who have loved me always. Unless otherwise noted, all photographs are courtesy of the Clinton County Historian's Office.

Introduction

Clinton County's location, nestled between the Adirondacks and the Green Mountains, situated alongside Lake Champlain, and partially held within the boundaries of the Adirondack Park, makes it a wonderfully photographic place to live, work, and visit. The postcards in this book vividly illustrate the appeal of New York's northeasternmost county, settled in the late part of the 18th century and currently celebrating the 225th anniversary of its charter.

The county's early history was heavily influenced by Samuel de Champlain's explorations of the areas now known as Quebec, New York, and Vermont. When Champlain arrived in 1608–1609, he found a rich, wooded area, full of fish and animals, but devoid of permanent settlements. For the most part, Native Americans had used the region for hunting and fishing expeditions and lived elsewhere. His travels, though, encouraged several generations of French Canadians to cross the border to live in northern New York. Although photography was not invented until long after Champlain's time, his presence is felt in this book, as it is felt throughout the county, through the stories and images of the 300th and 400th anniversaries of his explorations and the images and history of a people whose daily lives are influenced heavily by the lake that bears his name.

Beginning with a tour of Route 9, this book travels along the edge of Lake Champlain. Roughly coinciding with the "Old State Road," completed in 1793, Route 9 connects the northernmost (Rouses Point) and southernmost (Keeseville and Au Sable) points of Clinton County. According to Dwight Hamilton Hurd in *A History of Clinton and Franklin Counties*, Route 9 was developed with "the purpose of opening communication between Montreal and New York, and at once became a famous thoroughfare." At various points, the road overlaps with other streets, including Lake Street in Rouses Point; Margaret Street, City Hall Place, and U.S. Avenue in Plattsburgh; and Main Street in Au Sable. Two branches of the road, 9B and 9N, further connect the county's various towns and villages.

Those towns and villages are incredibly important to the county's history. Fourteen towns and four villages are situated here. They include the towns of Altona, Au Sable, Beekmantown, Black Brook, Champlain, Chazy, Clinton, Dannemora, Ellenburg, Mooers, Peru, Plattsburgh, Saranac, and Schuyler Falls, and the villages of Champlain, Dannemora, Keeseville, and Rouses Point. While each municipality has a distinct history, they share some common features, notably the work of the villages and towns—ranging from the purely agricultural to the definitively industrial—featured on postcards for each place. Additionally, when considering recreational activities, the towns and villages point both to outdoor activities, like boating, fishing, and hunting, and to more cultural activities, like theaters and historical events.

So, too, does the city of Plattsburgh. Long the hub of the county's governmental and economic life, Plattsburgh is pictured in hundreds of postcards. They show streetscapes, individual buildings,

factories, rivers, and statues. More than that, the postcards illustrate a way of life that existed in Plattsburgh and throughout the county. Many of the images focused on Plattsburgh actually relate or specifically refer to people and places in each of the county's other municipalities, showing that, though people claim allegiance to a smaller municipality, they identify themselves as residents of one larger county.

That all-encompassing nature of life in Clinton County also shows in the history of the military presence in the region. From the Revolutionary War, when Plattsburgh witnessed the Battle of Valcour, to the War of 1812, when the county saw action in the Battle of Plattsburgh, a military tradition took root. That tradition led to the creation of the Plattsburgh Barracks and, subsequently, the changes from Army Post to Army Air Force Convalescent Hospital, to Naval Training Center, to college for World War II veterans, and to Air Force Base. Each iteration led to new interactions between those stationed on the base and those living in the county. Few residents of Clinton County have been unaffected by that military presence and its continued legacy. Even those who were born after the base closed in 1995 are surrounded by monuments dedicated to those who served in various wars, by veterans who returned home after their service or retirees who chose to settle in Plattsburgh after having been stationed here, and by the very buildings that housed the military installations.

With the base came an increased need for tourist accommodations. In part related to the influx of visitors to the Citizens Military Training Camp, and in part related to the automobile culture that arose in the United States during the early part of the 20th century, more motels and hotels, motor inns, and bed and breakfasts sprang up across the county. They range from ultra-chic and expensive resort hotels like the Hotel Champlain, to more earthy and down-home accommodations like the Northdale Farm Tourists' Home. Regardless of their cost and location, though, local inns lauded the history and culture of the region, often providing excursions to local tourist attractions and arranging musical evenings, lecture series, and other festivities. Not surprisingly, many of these festivities encouraged the intermingling of personnel from the military installation, tourists, and local residents.

Given the county's proximity to Lake Champlain and wide network of rivers, streams, ponds, and smaller lakes, many special events have occurred on or near the water. The annual Mayor's Cup Regatta in Plattsburgh is just one such event; the 300th and 400th anniversaries of Champlain's journeys highlighted the lake as well. Visitors to the county, like residents, keep an eye open for the mythical lake creature named Champy while extolling the beauty of the various waterways. In the case of Paul H. Hartman and Henry Ehlers, that love inspired a song, "Old Champlain" (1942): "The Saranac curves swiftly down / From mountains dark with pine, / By night and noon its woody slopes / With silver birches shine. / From north and south and from the west / The land is split in twain / By brooks that speed the Saranac / To old Champlain!"

Not only blessed to be situated on the lake, Clinton County has the good fortune to count some 14 museums and historical associations within its boundaries. Those groups, most of which belong to the newly formed Adirondack Coast Cultural Alliance, work to maintain the history and culture of the region. Especially important to the history of the region are the Alice T. Miner Museum, the Anderson Falls Heritage Society, the Babbie Rural and Farm Learning Museum, the War of 1812 Museum–Battle of Plattsburgh Association, the Champlain Valley Transportation Museum, the Clinton County Historical Association and Museum, the Friends of Lyon Mountain Mining and Railroad Museum, the Kent-Delord House Museum, the North Country Underground Railroad Historical Association (located near Au Sable Chasm, technically in Essex County, but surrounded by Clinton County and actively involved in the history of both), the Northern New York American-Canadian Genealogical Society, the Rouses Point–Champlain Historical Society, the Samuel de Champlain History Center, and State University of New York (SUNY) College at Plattsburgh Special Collections. All of these groups, as well as the municipal historians throughout the county, are assisted by the Champlain Valley National Heritage Partnership and the Lakes to Locks Passage, two associations designed to shine a light on the history of the Lake Champlain region.

One

Route 9

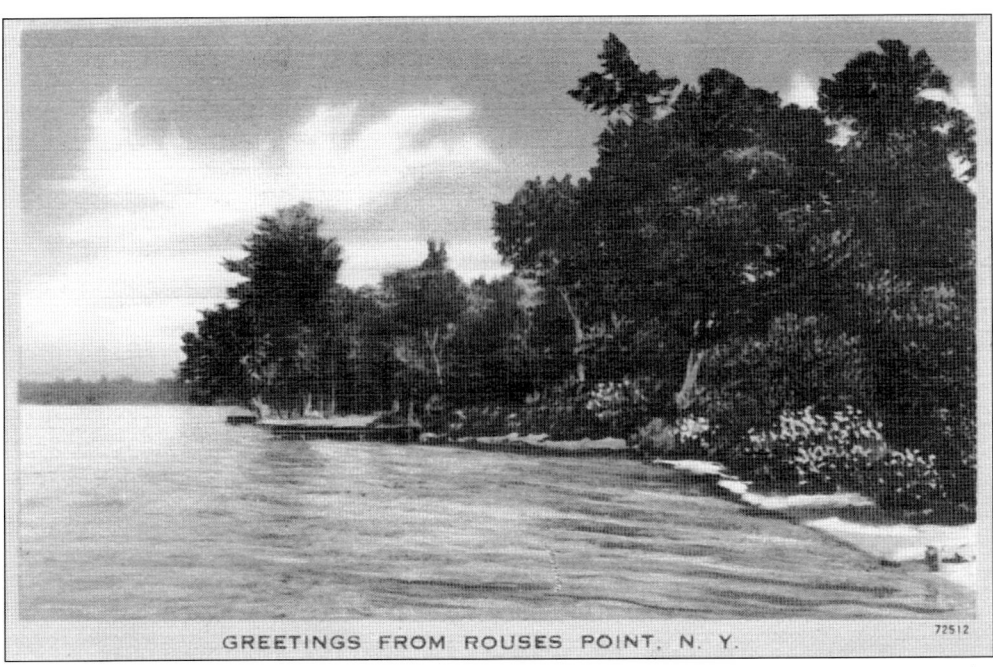

The Reverend John Talbot described Rouses Point as, "A struggling homely town situated at the very point where the Lake empties into the Richelieu River. Its surroundings are majestic and beautiful. The broad sweep of the blue Lake is visible for 7 or 8 miles to the south. Behind its wooded shores rise the Green Mountains on the east, and on the west the somber Adirondacks." (Courtesy of Gary Wells.)

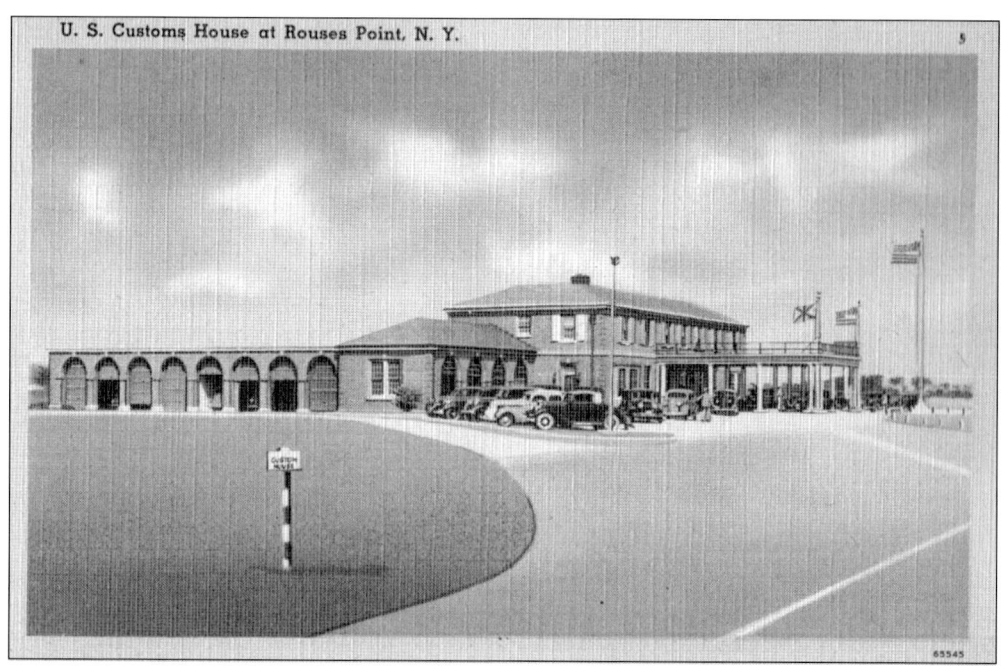

Quebec and New York share 10 border crossings, 6 of which are located in Clinton County. During Prohibition, this crossing at Rouses Point, named for Jacques Rouse, was particularly popular. Travelers were expected to stop for inspections and make their declarations at the separate customs house, located on Lake Street. In later years, Sam Racicot remembered this station, saying, "During my six years as a bootlegger, I never met one dishonest law enforcement officer locally. None would take a bribe of cash or booze. When I wasn't out on the road, I spent a lot of time hanging around the Rouses Point customs house talking with the officers and learning what I could." (Above, courtesy of the Cole Collection, Plattsburgh Public Library; below, courtesy of the Ron Venne Collection, used with the permission of his family.)

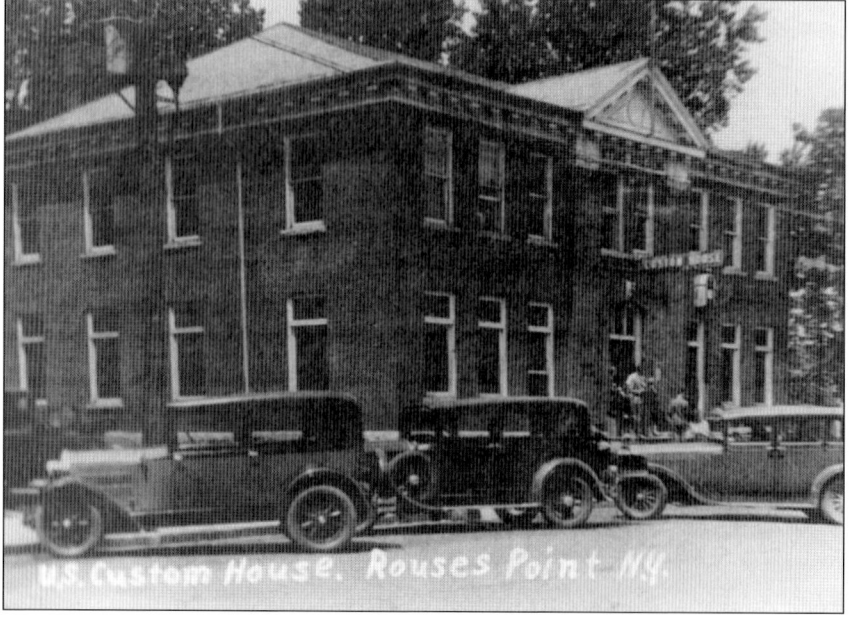

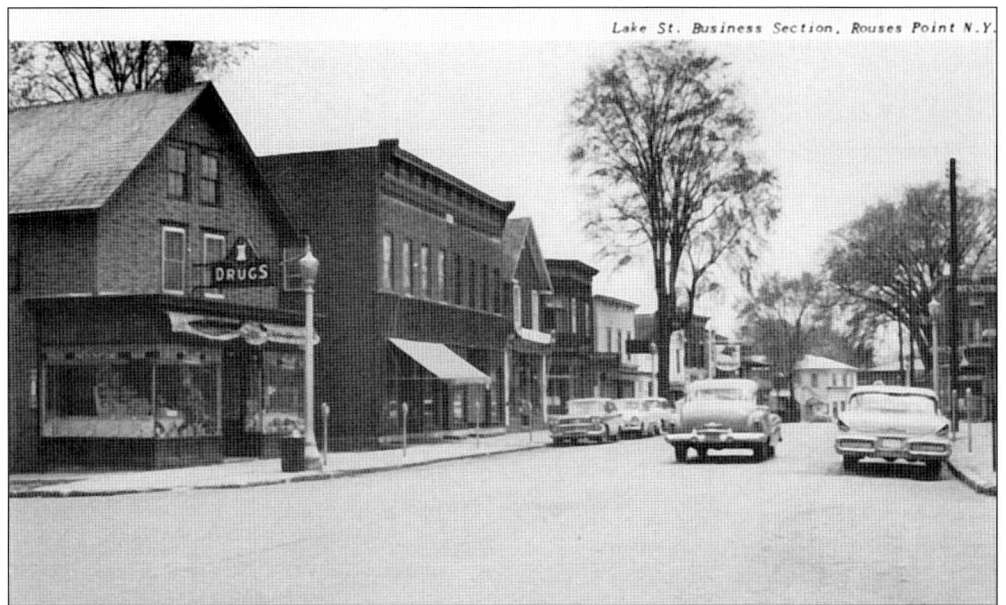

Lake Street, Rouses Point's main street, roughly follows the lake shore and boasts local businesses including a marina, restaurants, specialty stores, a library, motels, and St. Patrick's Church. The village offices and a civic center are also on Lake Street. After an 1809 visit, E.A. Kendall Esq. described Rouses Point as "a famous, renowned, booming, thriving, truly located, advantageously situated, highly privileged and busy Lake port of Lake Champlain." (Courtesy of Gary Wells.)

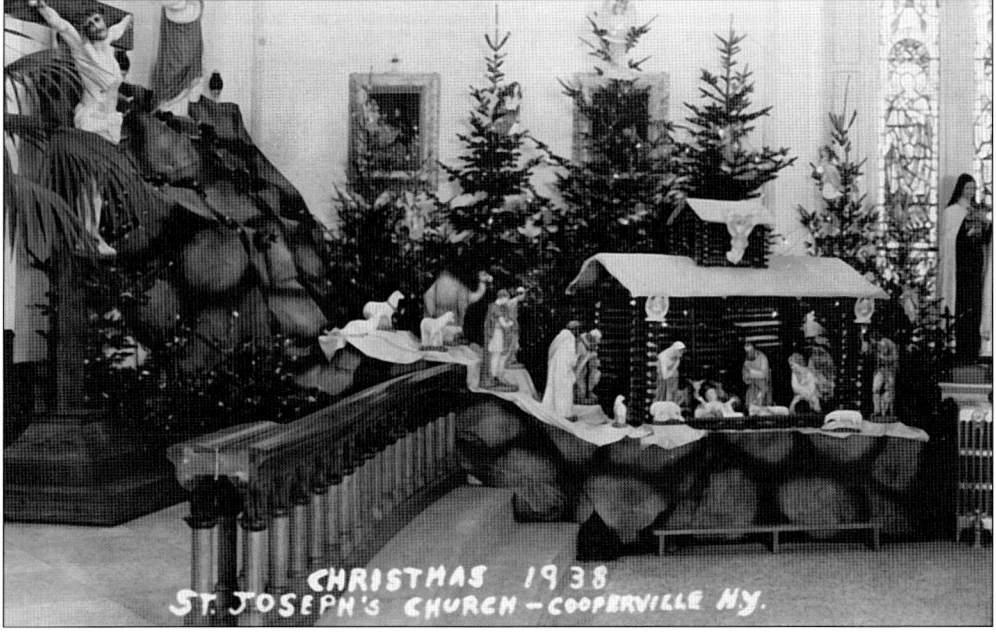

St. Joseph's Church, Coopersville, was considered the "Old Mother Church" because five local missions (St. Mary's in Champlain, St. Patrick's in Rouses Point, Sacred Heart in Chazy, St. Ann's in Mooers Forks, and St. Louis de France in Sciota) were established from this parish. The first two churches on the site burned (in 1823 and 1934). In 2013, the church became an oratory, only hosting weddings and funerals. (Courtesy of Gary Wells.)

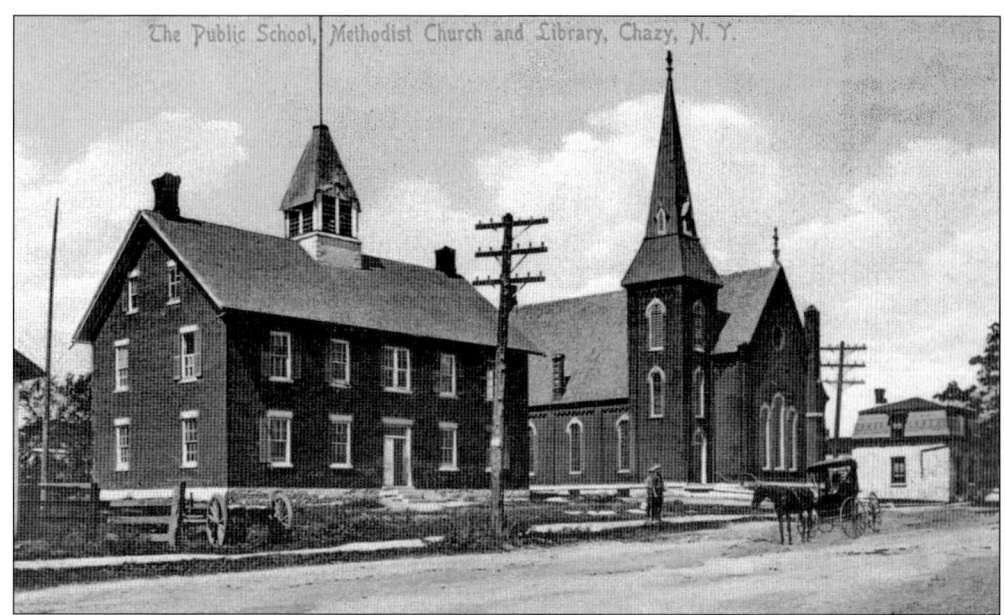

Route 9 runs through the heart of Chazy. Pictured here from left to right are the Chazy School Building, which became the front part of Gray Gables; the Methodist Episcopal Church, now the Town of Chazy offices; and the stone library, which has recently moved to another historic structure in town, formerly the house and law office of Julius C. Hubbell. (Courtesy of the Cole Collection, Plattsburgh Public Library.)

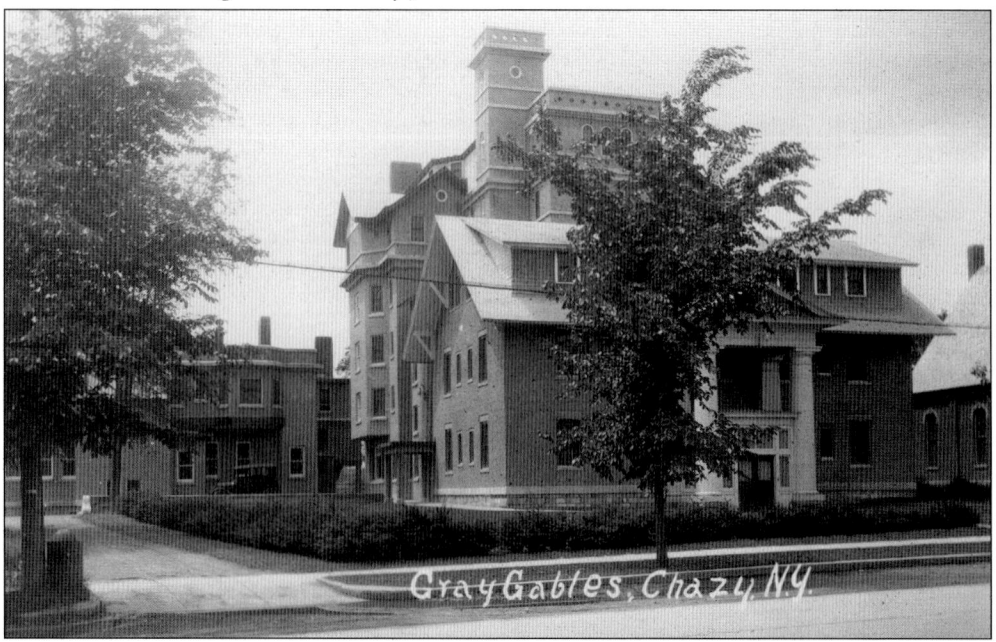

The front portion of Gray Gables was built in 1871 and used as Chazy's village school from 1874 until 1916. An annex, known as the "teacherage" was added in 1922. Built on solid rock, Gray Gables was used to house teachers, who could go to the old school via a tunnel. Sold in 1963, the structure has been used as apartment buildings ever since. (Courtesy of Cole Collection, Plattsburgh Public Library.)

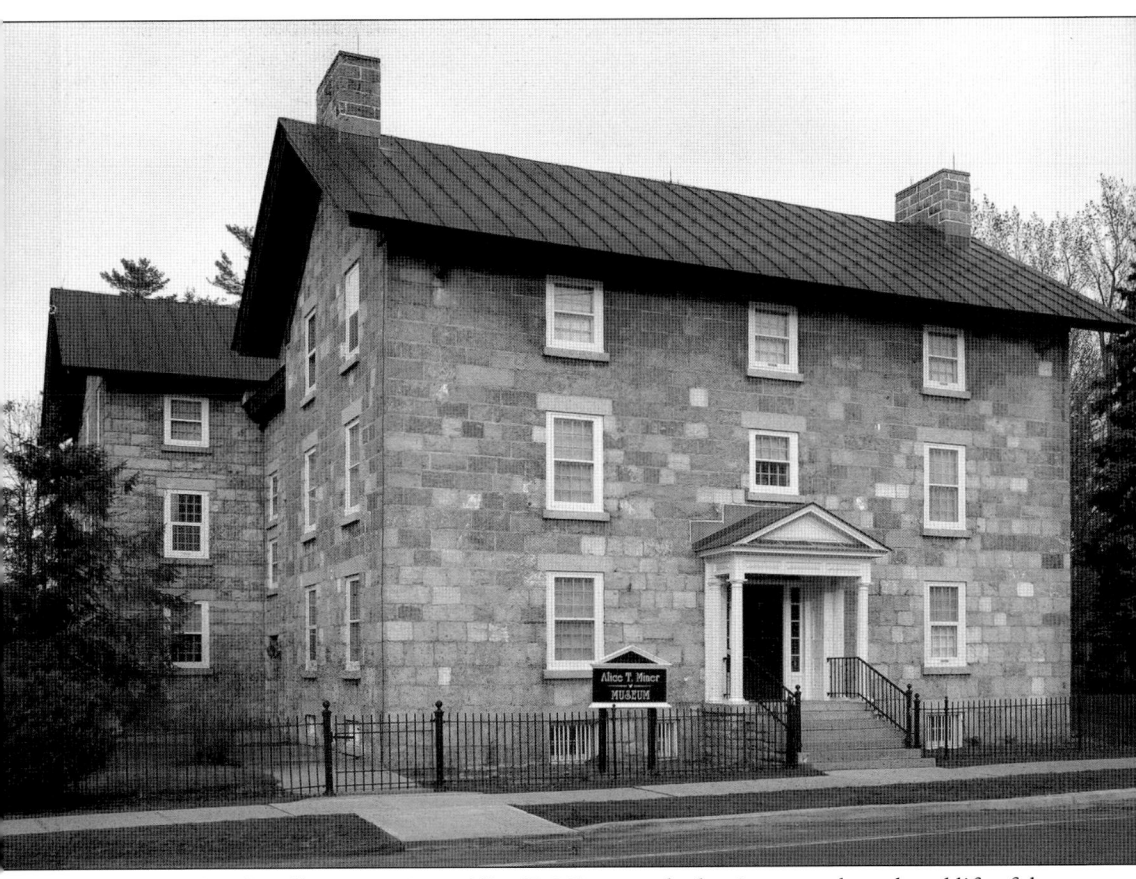

With her husband William H. Miner, Alice T. Miner worked to improve the cultural life of the region. One effort in that direction was the Alice T. Miner Colonial Collection, a three-story house museum located on Route 9 next to the Chazy Central Rural School. According to the museum's literature, the collections center on two themes: Alice's personal taste, and those of her Chicago friends and the Colonial Revival movement. Included in the collection are a Colonial kitchen, a formal dining room, a ballroom with a vaulted ceiling, and the Lincoln room, which contains books, documents, and letters related to all of the presidents, as well as to other famous Americans. Specific artifacts range from pewter table settings to collections of china, samplers to silhouettes, quilts to dolls, and formal furniture to children's furniture. Visitors to the museum are led through each room on a guided tour, learning about the history of the house and artifacts from trained docents. (Photograph by PHOTOPIA/Shaun Hefferenan; courtesy of the Alice T. Miner Colonial Collection.)

Fantasy Kingdom, a small theme park just north of St. Armand's Beach in Point au Roche, was designed and built by Norman Dame Sr. Opening in 1957, the park included a giant's castle, a floating model of the Jolly Roger pirate ship, a petting zoo, a train ride, and several houses tied to fairy tales and children's stories. Sadly, the park closed within six years.

Inspired by a Montreal restaurant, the Orange Julep opened in the late 1950s on a site next to Gus' Red Hots and later moved to this site on Route 9. Included among its offerings were a signature Orange Julep (25¢ for a pint, 50¢ for a quart), a burger in a basket with French fries (50¢), a Michigan (30¢), fried clams, and other seafood. (Courtesy of the Ron Venne Collection, used with the permission of his family.)

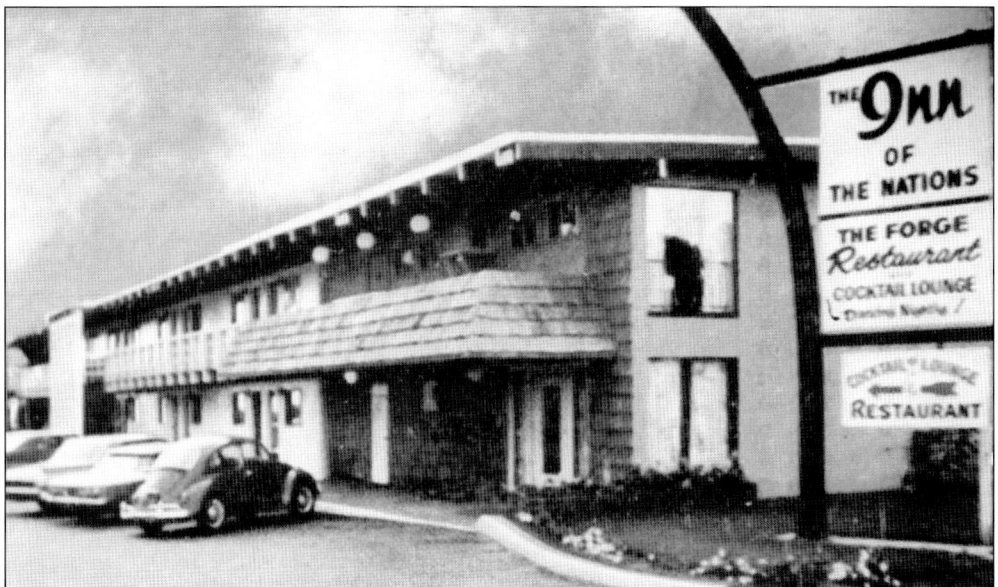

Small motels like the Inn of Nations are scattered from one end of Route 9 to the other. These motor inns served travelers passing through the county for most of the 20th century. When the Adirondack Northway (also known as Interstate 87 and the Adirondack Veterans Memorial Highway) was constructed in the 1960s, many of these roadside inns became apartment buildings. (Courtesy of the Ron Venne Collection, used with the permission of his family.)

Situated on Lake Champlain, Cumberland Head offers sandy beaches and fertile farmland. Fort Izard was constructed on Cumberland Head in 1814; though it was used briefly, the site was quickly abandoned in favor of defensive structures in the village of Plattsburgh. Later, during the 19th century, Cumberland Head sported stores, a tavern, and a steamboat stop at the wharf.

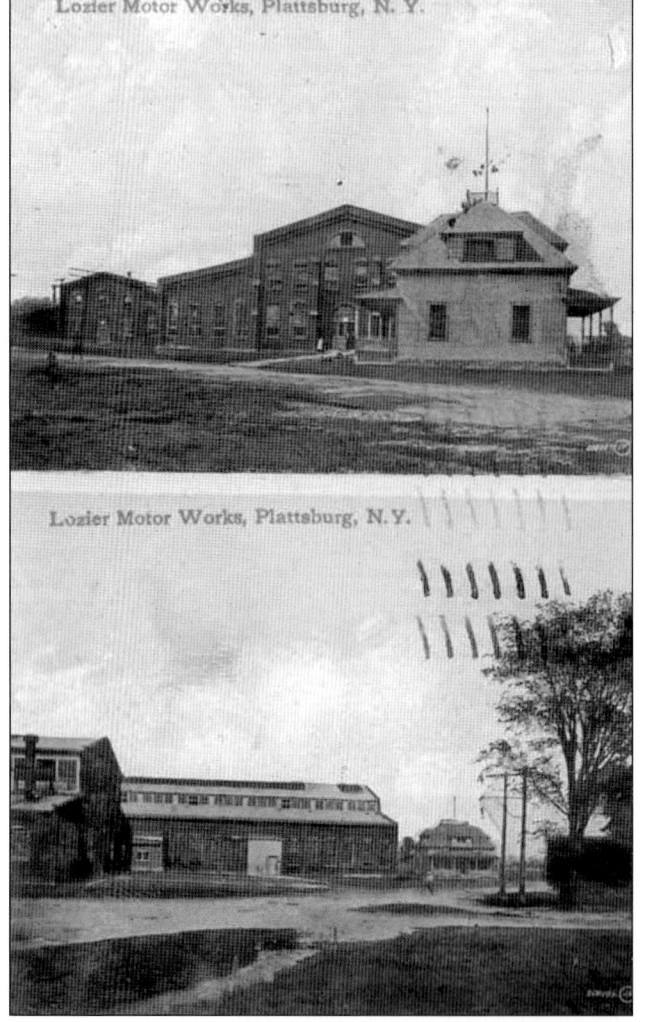

Beginning with their production of boats, Lozier became synonymous with luxury. The company began producing boats in 1900 and cars in 1904. In both cases, their product was expensive, fast, and desired by the wealthiest. Focusing on the niche market proved disastrous for the Plattsburgh company: their production of extravagant automobiles flew in the face of the movement toward much less expensive cars and led to bankruptcy in 1915.

The Lozier Collection, which includes these two cars, is the centerpiece of the Champlain Valley Transportation Museum. Located on the museum campus, which is part of the former Plattsburgh Air Force Base, the transportation museum was founded in 2000 with a mission to "preserve, interpret, exhibit, and educate regarding transportation history and artifacts in the Champlain Valley." (Courtesy of the Champlain Valley Transportation Museum.)

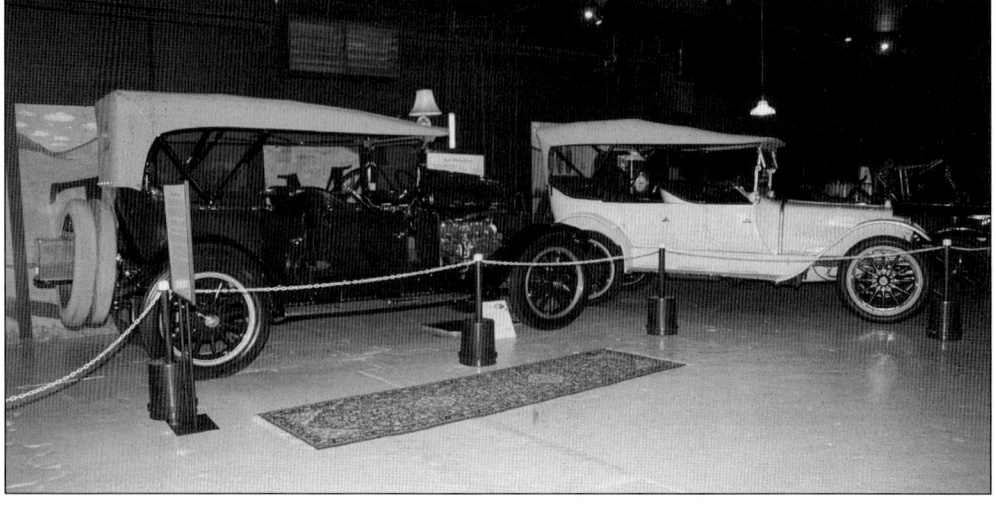

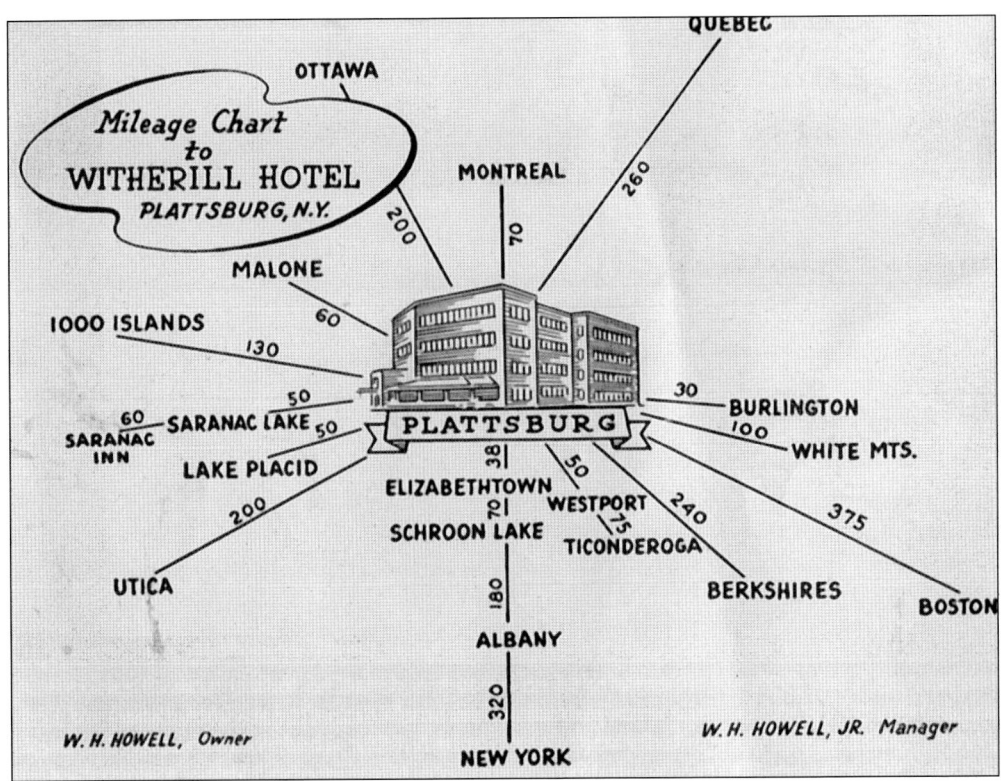

As the Hotel Witherill demonstrated to its guests in a commemorative postcard booklet, Plattsburgh—and, indeed, all of Clinton County—is within an easy drive of many points of interest. Montreal, Burlington, and Lake Placid are three particularly popular tourist spots, each within a couple of hours of the city. For many years, Route 9—on which the Hotel Witherill was located—served as one of the main thoroughfares to allow tourists to make those day trips. Originally called the New York to Montreal Highway, the road was known to locals as the "State Road." Today, local traffic has been largely rerouted to Interstate 87, though the far more scenic Route 9 is still used. (Both, courtesy of Gary Wells.)

ONE-DAY TRIPS FROM PLATTSBURG

No. 1 — Through the Adirondack Mountains to
 Ausable Chasm
 Whiteface Mountain Memorial Highway
 Lake Placid
 Saranac Lake
 and return to Plattsburg
 100 Miles

No. 2 — To Montreal and return to Plattsburg
 140 Miles
 No passport required

No. 3 — To Vermont
 Lake Champlain island trip via
 Rouses Point Bridge to
 Burlington and ferry to
 Port Kent
 and return to Plattsburg
 88 Miles

MAKE THE WITHERILL YOUR HEADQUARTERS
WHILE USING THE
WHITEFACE SKI CENTER

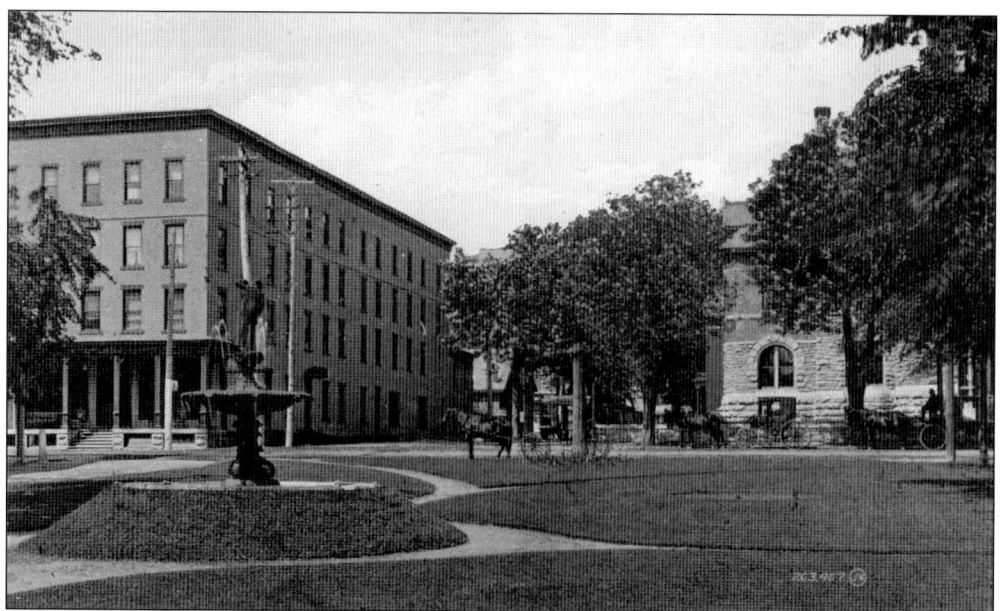

Continuing south on Route 9, motorists would soon find themselves in the heart of downtown Plattsburgh. Trinity Park, shown here, lies on Route 9 (also known as City Hall Place, Court Street, Margaret Street, and Trinity Place). Visitors could stop to relax in the park, walk over to the Cumberland Hotel to eat a meal or book a room, or do business at the Plattsburgh Court House or City Hall.

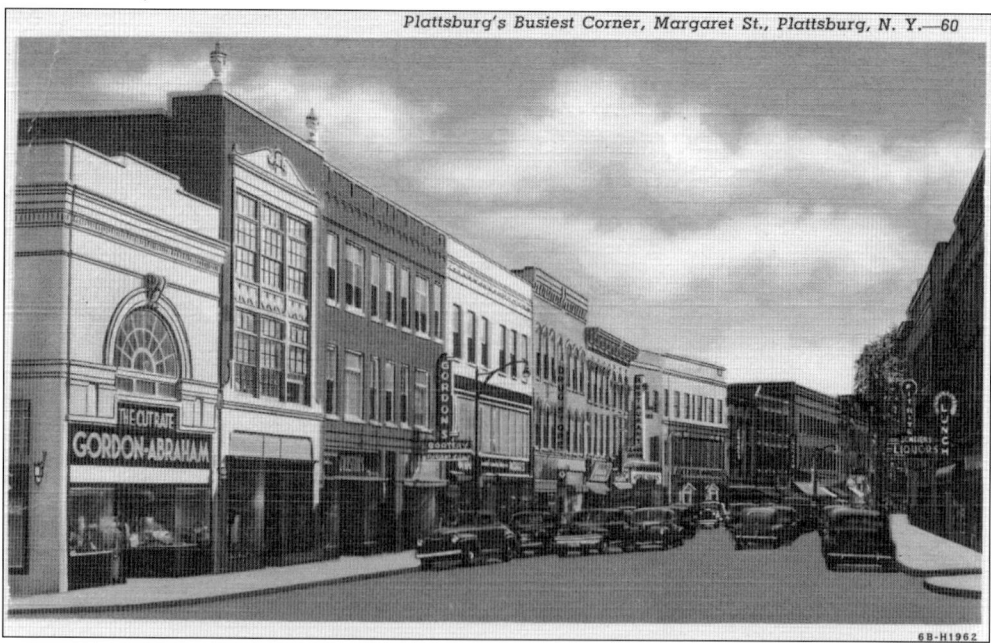

In the city of Plattsburgh, Margaret Street forms part of Route 9. A 1930 *Plattsburgh Sentinel* editorial advocating for better street signs and numbering proclaimed, "Margaret Street is the most important street in town. It is one of the principal business thoroughfares besides being the street over which there is the most traffic. The most important part of Margaret street is at the junction of Bridge," shown here.

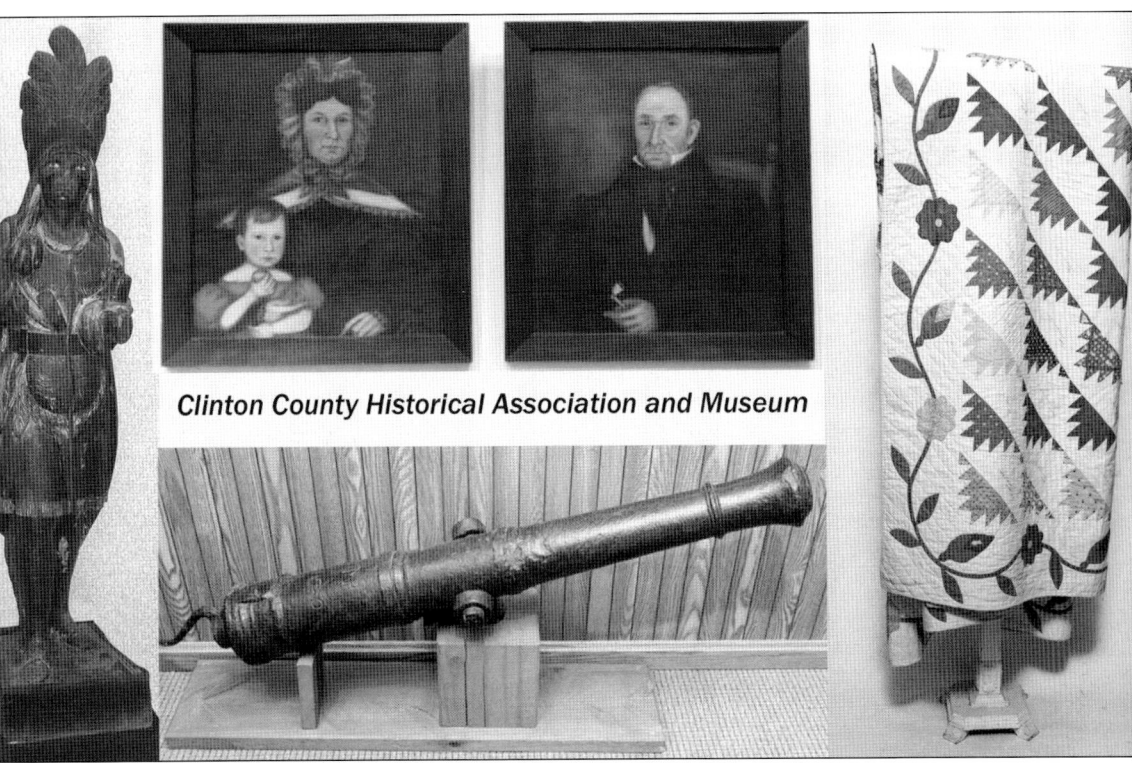

Formed in 1945, the Clinton County Historical Association takes as its mission the preservation of the county's heritage. The museum's goals are: "to preserve and publicize the history of Clinton County, New York; to illuminate the past and interpret its meaning for visitors to the museum; to acquire and preserve historical treasures which are the heritage of the people of Clinton County; and to educate succeeding generations in the rich history of the Champlain Valley within the larger framework of the history of the United States." Those goals include the association's projects to conserve artifacts—ranging from paintings to glass plate negatives and dioramas—held in the museum, to preserve the Valcour Island Lighthouse, to acquire suitable items for the collection, and to provide educational programs for children and adults. Currently situated on the museum campus at 98 Ohio Avenue, the museum was previously located on the third floor of city hall (1972) and 48 Oak Street (1992). (Courtesy of the Clinton County Historical Association.)

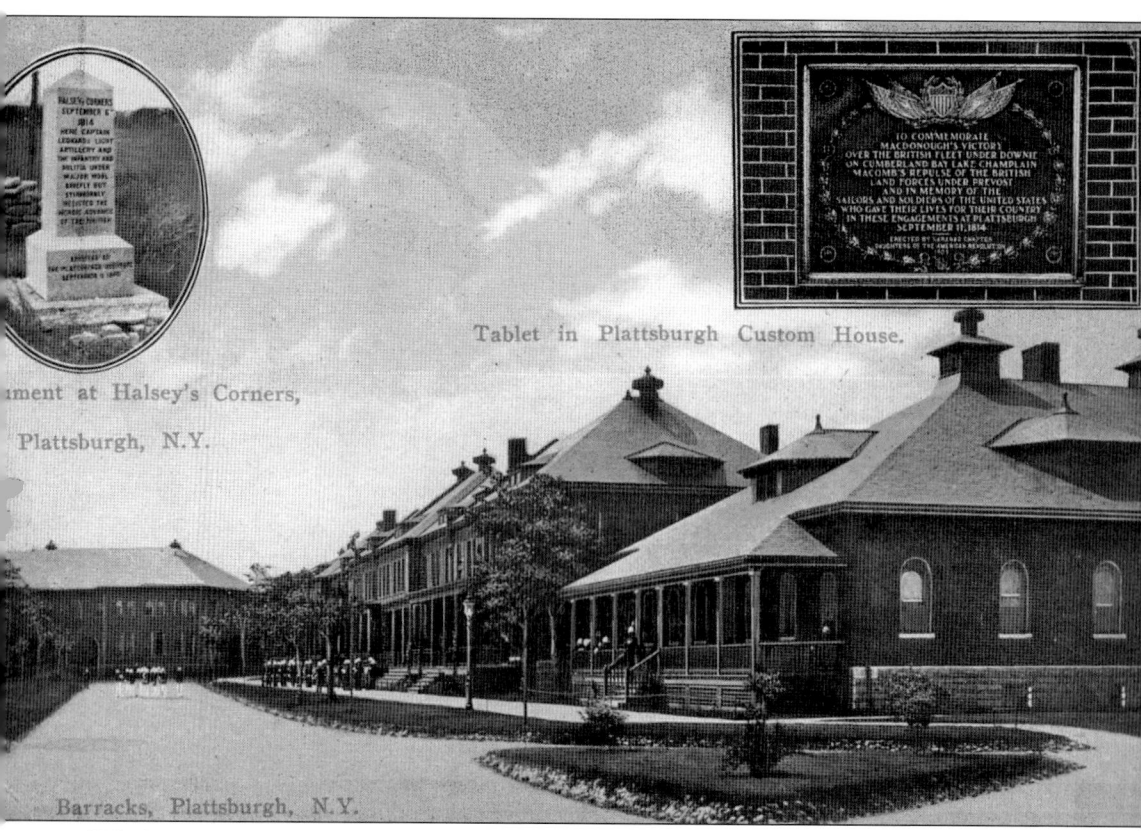

U.S. Avenue, one portion of Route 9, winds in front of the former Plattsburgh Barracks, pictured here. Although construction of the barracks did not begin until 1839, the monuments shown here commemorate the Battle of Plattsburgh, which occurred during September 1814 and which was a very significant part of Clinton County's history. The obelisk shown in the upper left is situated at Halsey's Corners, a site in the town of Plattsburgh. Erected by the Plattsburgh Institute in 1895, the monument commemorates the skirmish that occurred at Halsey's Corners leading up to the Battle of Plattsburgh. The plaque shown in the upper right was placed in the Plattsburgh Customs House by the Saranac Chapter of the Daughters of the American Revolution in 1903 to commemorate the US victory at the Battle of Plattsburgh. Each year, during the Battle of Plattsburgh commemoration, these sites are remembered, as are those who fought during the battle.

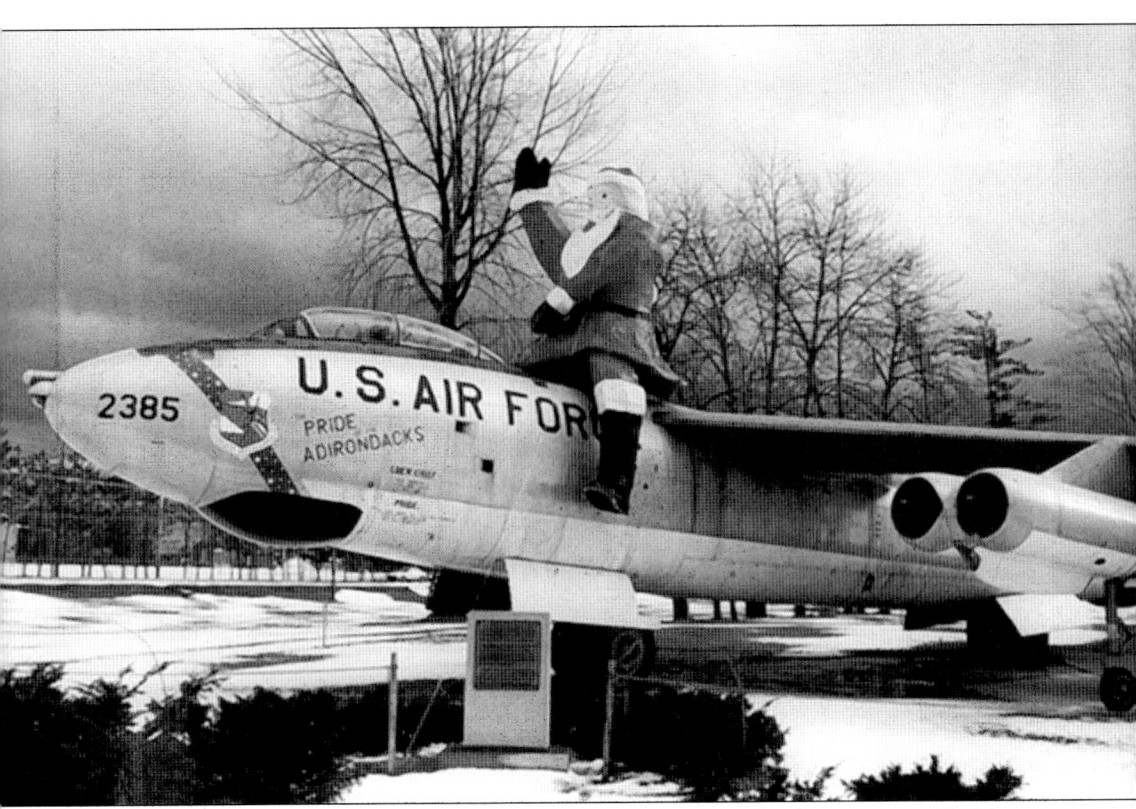

Perched on the *Pride of the Adirondacks*, a retired B-47, Santa Claus has been an annual visitor to the region since the 1970s. Thirty feet high, Santa is made of wood, canvas, and chicken wire. In the early part of the 21st century, some 10 years after the Plattsburgh Air Force Base closed, this plane and its neighbor, an FB-111, were moved from one side of Route 9 to the other. Originally located near the former base hospital, they now sit in Clyde Lewis Park, named for the man who was a driving force in bringing the Air Force to Plattsburgh. The planes are near a newly-formed museum campus that houses the Clinton County Historical Association, the Battle of Plattsburgh Association, and the Champlain Valley Transportation Museum. (An Air Force Museum is also planned for the campus.) Though Santa still visits every year, he now peeks from the top of an oversized chimney, sitting beside the planes instead of astride one.

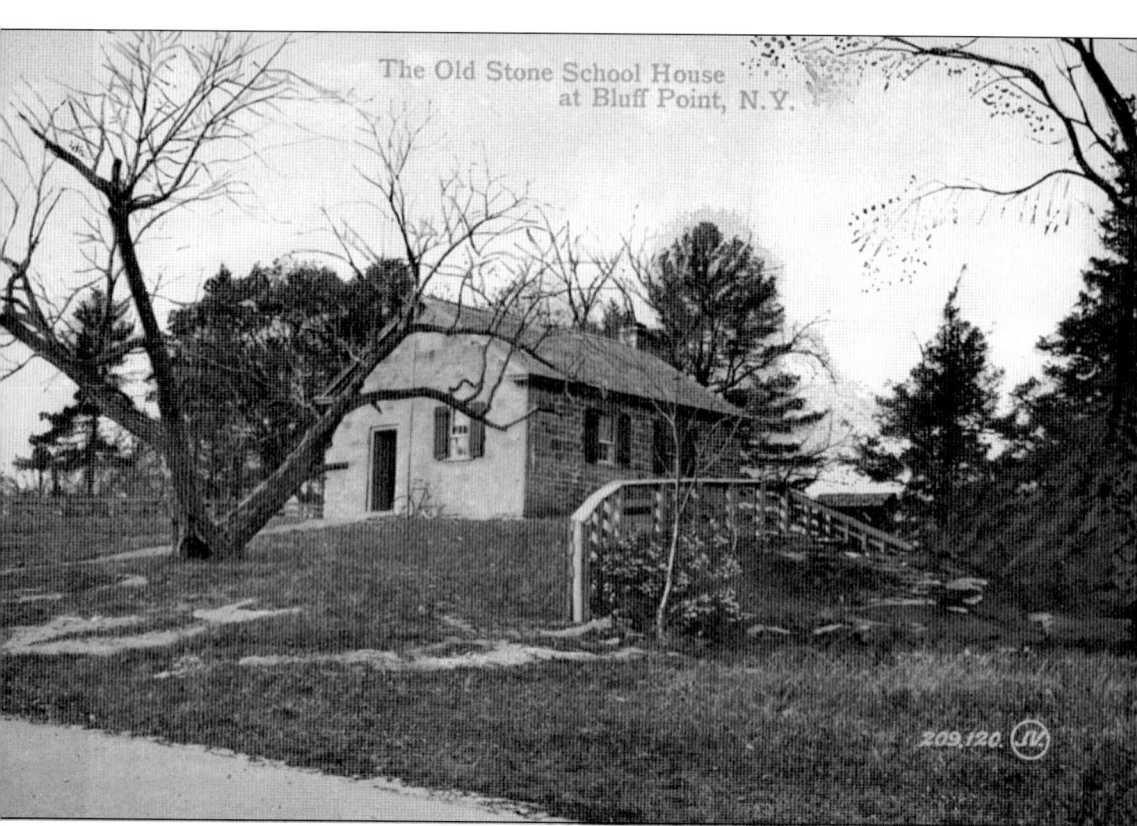

Bluff Point is located in the town of Plattsburgh, near the line separating Plattsburgh from Peru. Prior to the centralization of schools, this stone schoolhouse was known as School District No. 19 and served local residents, most of whom walked at least two miles to attend. In 1904, its assessed value was $250. (Courtesy of the Cole Collection, Plattsburgh Public Library.)

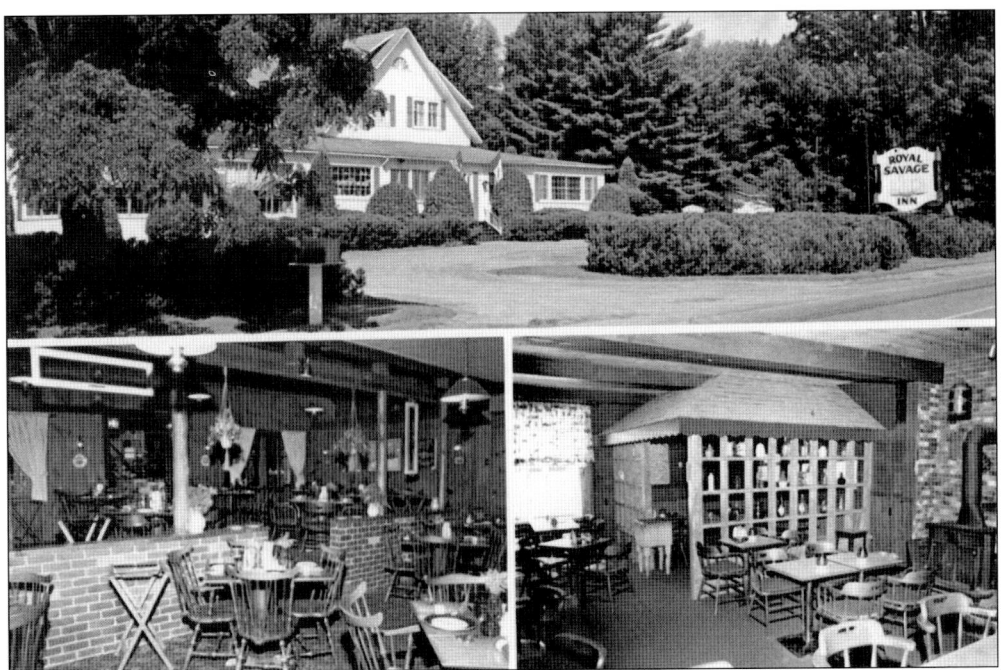

Started by the Booth family in 1905, the Royal Savage was a longtime North County tradition. Known for its Yankee food, the restaurant included popovers and an apple crunch dessert as particular specialties. After being leased to Evelyn Parkhurst, and then leased and sold to Newton and Marion Keith, who ran the restaurant for 38 years, the Royal Savage was purchased by Don Benjamin in 1970. Sadly, in 2003, the restaurant closed permanently. Named for a two-masted schooner that fought in the Battle of Plattsburgh, the Royal Savage is now being restored to its original exterior and will be used as a private residence. (Above, courtesy of Elizabeth Botten; below, courtesy of Dick Lynch.)

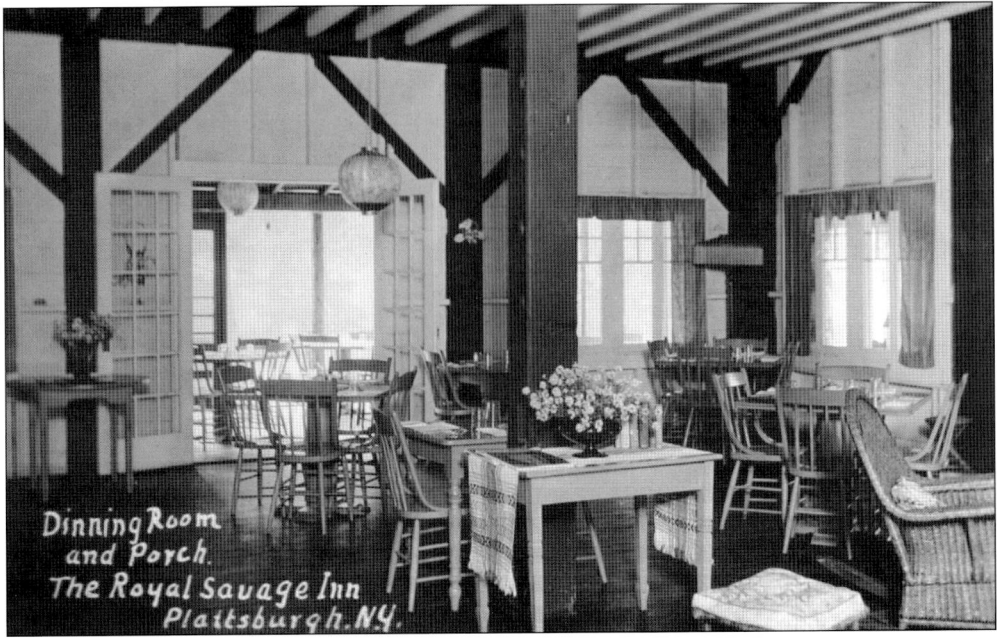

From the very northernmost part of the county to the southern tip, Route 9 travels close to Lake Champlain. Though it winds through villages, farmland, and the city of Plattsburgh, the road is most famous for lake views like these, still visible in the town of Peru, just south of the line dividing the town of Plattsburgh from Peru. Motorists traveling along this road see the Green Mountains in the distance and several islands. The most notable of these, Valcour, is famous for its role in the Battle of Valcour during the Revolutionary War and its excellent camping and day trip possibilities.

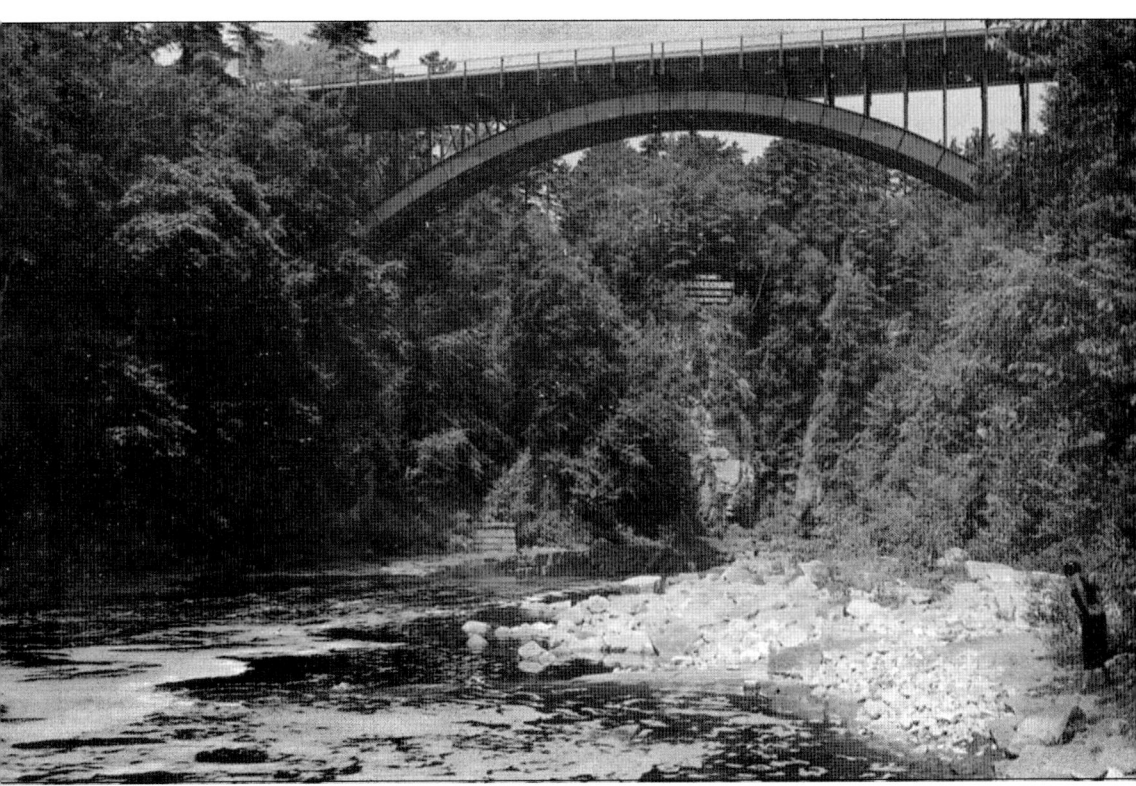

Travelers on Route 9 cross into Essex County as they approach Au Sable Chasm and back into Clinton County after they pass it. Open since 1870, the Chasm offers walking tours, rafting, tubing, and a museum. In 1907, Seneca Ray Stoddard wrote, "to the scientist it is interesting as illustrating rock fracture and erosion; to lovers of the strange and beautiful, a place of wonder."

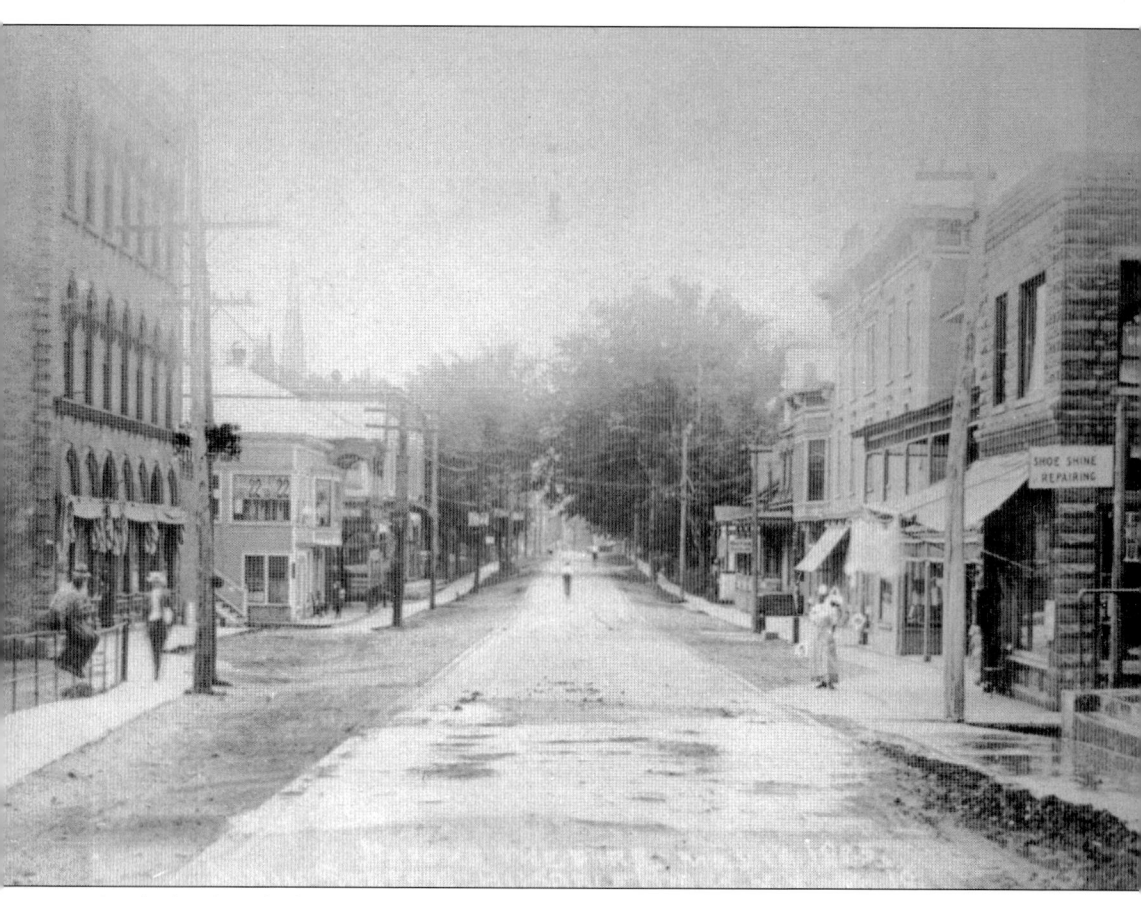

On the border of Clinton and Essex Counties, Au Sable Forks was a company town, established by iron mining companies to house the largely immigrant population that worked in the mines. Main Street, pictured here in 1925, is located on US Route 9N, an offshoot of Route 9 that serves as an east-west thoroughfare. (Courtesy of the Ron Venne Collection, used with the permission of his family.)

Two

Around Town

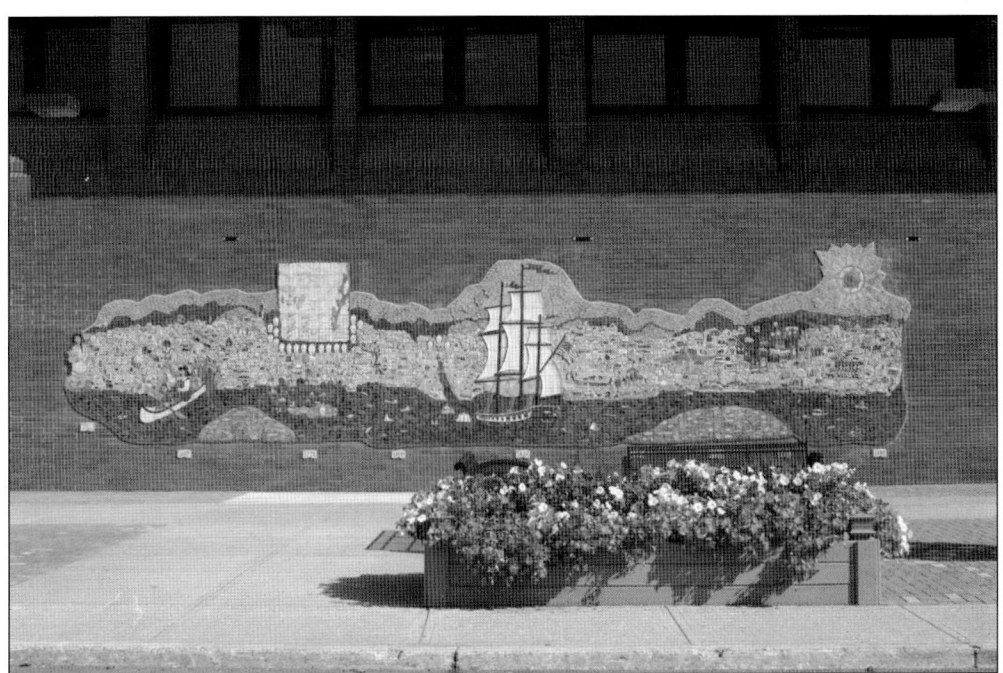

Created by students from around the county, the *Clinton County History Through the Eyes of Its Children* mosaic is 38 feet long and, at its highest point, 9 feet tall. The mosaic was installed on the wall of the Clinton County Government Center and unveiled in August 2009. The mosaic represents the history of every municipality within the county and illustrates the region's landscape.

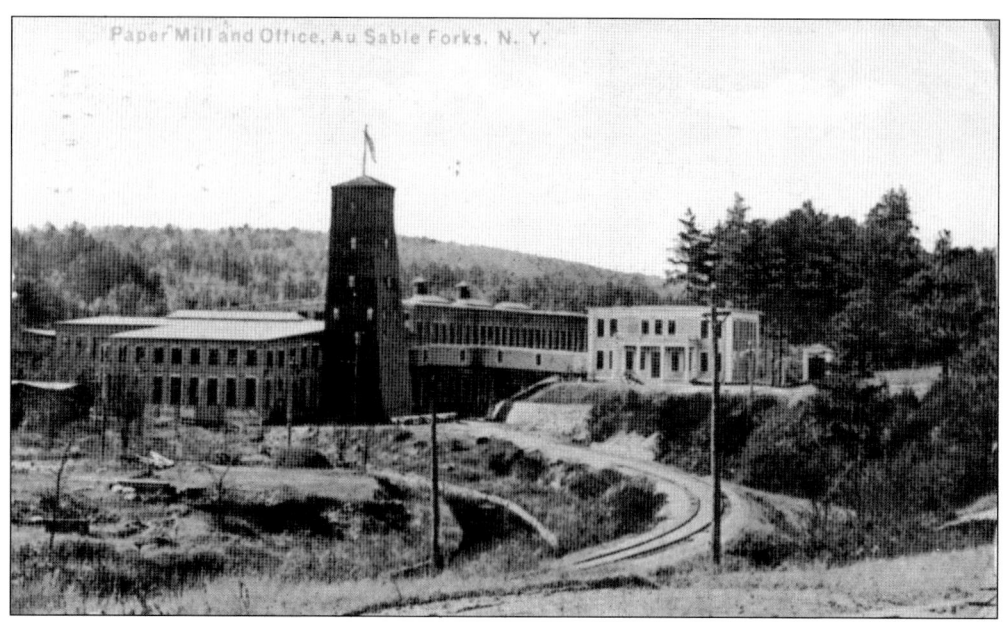

Located in the town of Black Brook, the paper mill was originally owned by the J. and J. Rogers Company. A major employer in Au Sable and Black Brook, the Rogers Company first operated this site as an iron mill and then as a pulp and paper mill. Sold in 1955, the mill continued to operate until a decline in the demand for paper products forced it to close.

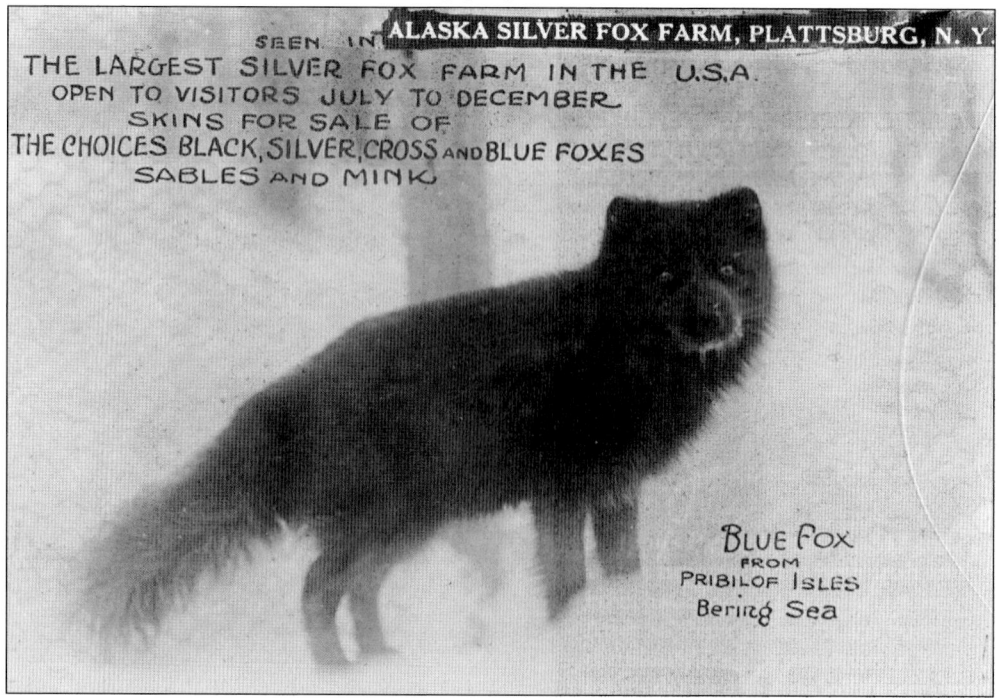

The Alaska Silver Fox and Fur Farms Company was situated just outside of Plattsburgh. With a 40-acre site, this was the largest American ranch dedicated to fur production in 1917. Managed by J.S. Sterling, the farm boasted 108 silver foxes, 5 cross foxes, 4 blue foxes, 12 mink, and 14 Alaska sable. (Courtesy of the Cole Collection, Plattsburgh Public Library.)

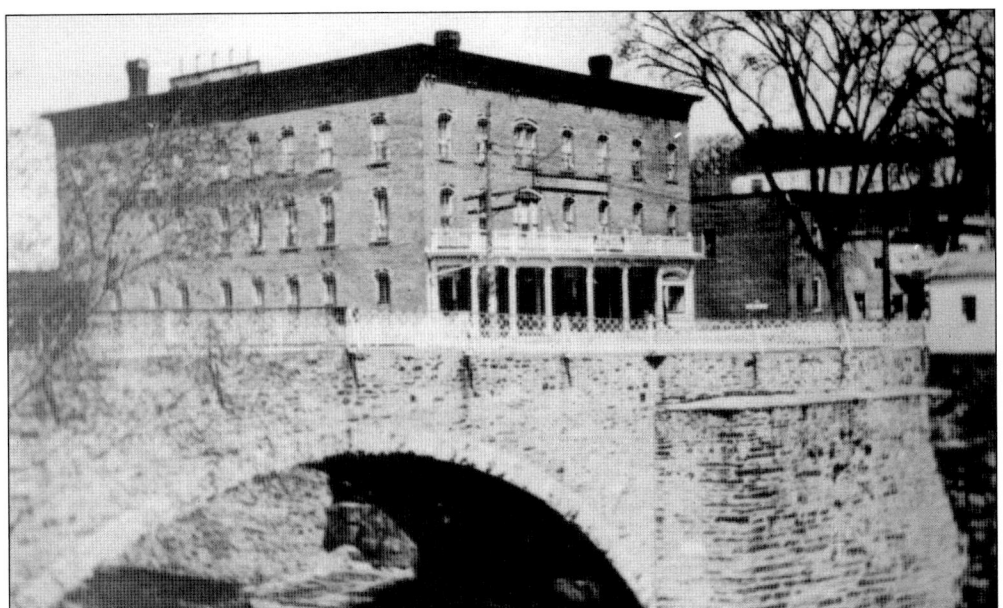

Keeseville, a village that rests both in Clinton and Essex Counties, was originally named Anderson Falls. Around 1812, the name of the village was changed to honor the Keese family. Prominent as local businesspeople and manufacturers, the Keese family was also active in the Underground Railroad. Due to the abundant water supply, mills were especially prosperous in this village. (Courtesy of the Ron Venne Collection, used with the permission of his family.)

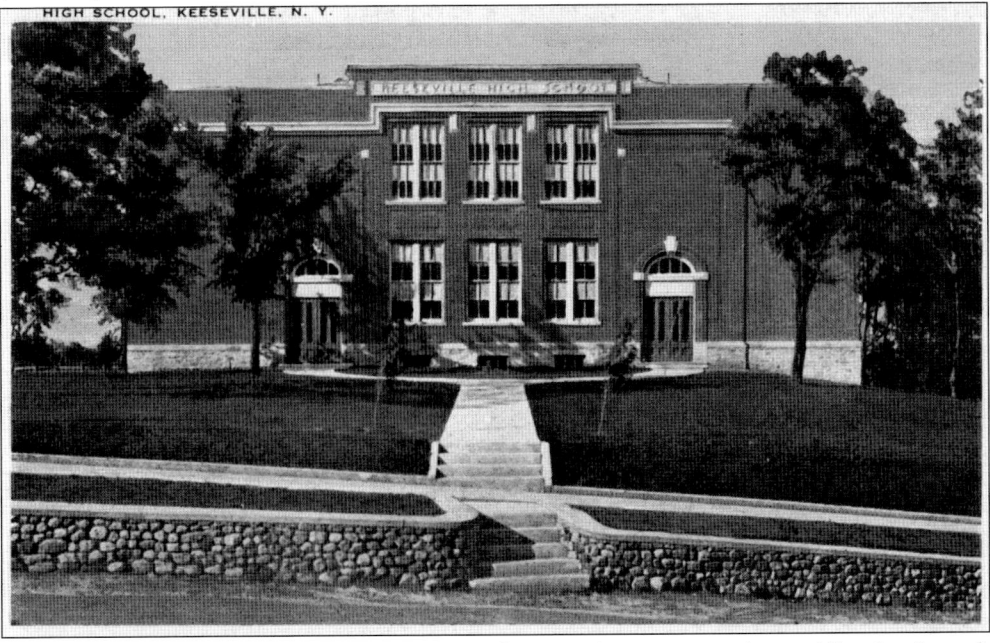

The Keeseville Central School, built in 1936 on the same site as two previous public schools, each known as the Keeseville Academy, served students in the Keeseville area. Further consolidation and centralization as the Au Sable Valley Central School led to the closure of this building, which is now known as the Keeseville Civic Center. When the village offices moved across the street, the facilities were vacated. (Courtesy of the Cole Collection, Plattsburgh Public Library.)

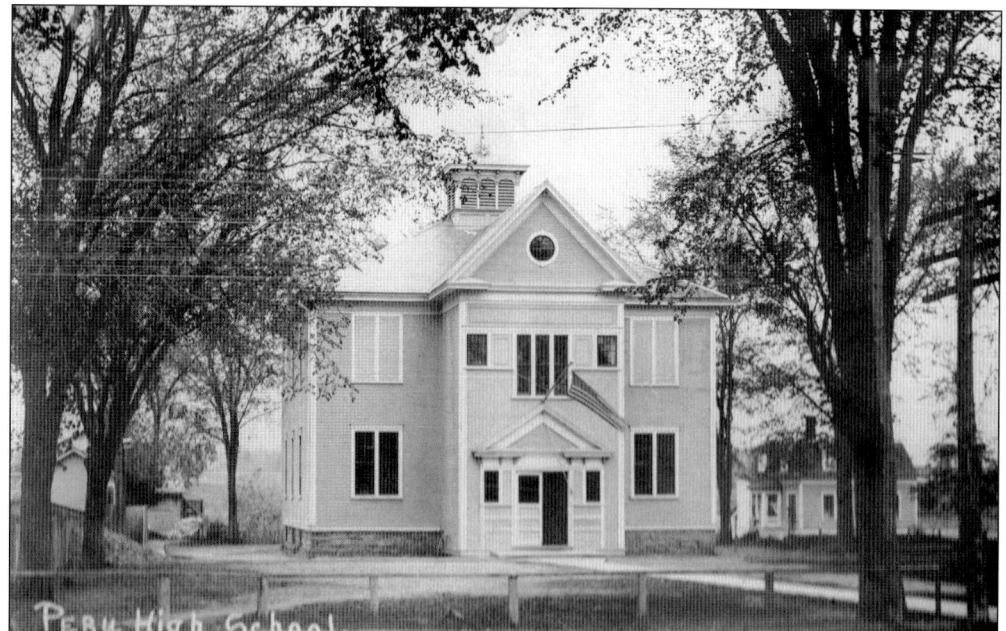

Situated on the south side of Pleasant Street, this wooden structure served as Peru's high school until the "new" brick Greek Revival school was built on the north side of the street. Eventually, the school district expanded further, adding a primary school, using the newer brick building as an elementary school, and constructing a separate junior-senior high school on the same large lot bordered by Route 22B and School Street. (Courtesy of the Cole Collection, Plattsburgh Public Library.)

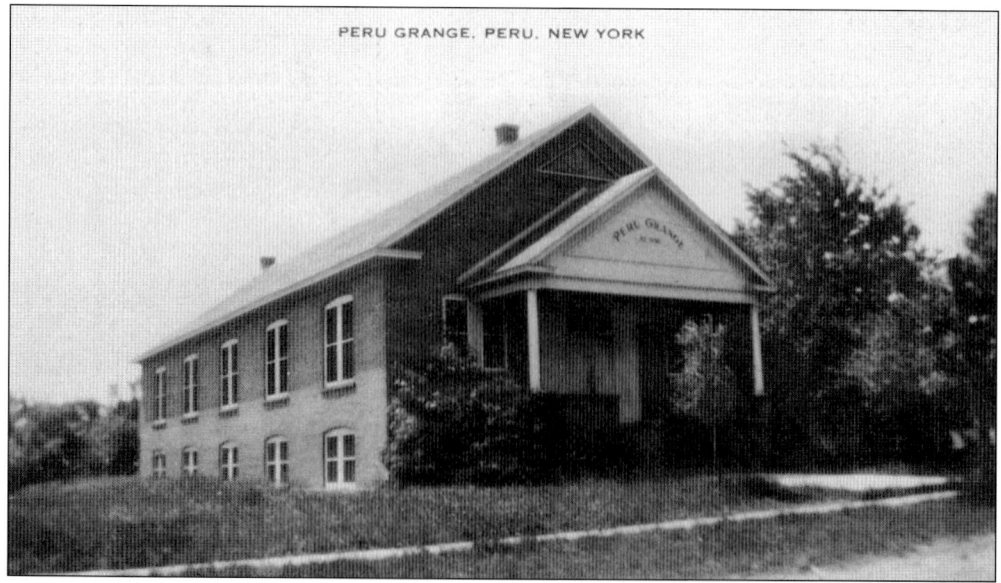

The Peru Grange was situated on Main Street across from St. Augustine's Church on the site of the current Peru Town Hall. As part of its mission to promote "cultivation of a pride and interest in the home, in the farm, in one's town and country," the Peru Grange published *Reminiscences and Early History of Old Peru* in 1913, hoping to add information to and preserve the town's history. (Courtesy of the Cole Collection, Plattsburgh Public Library.)

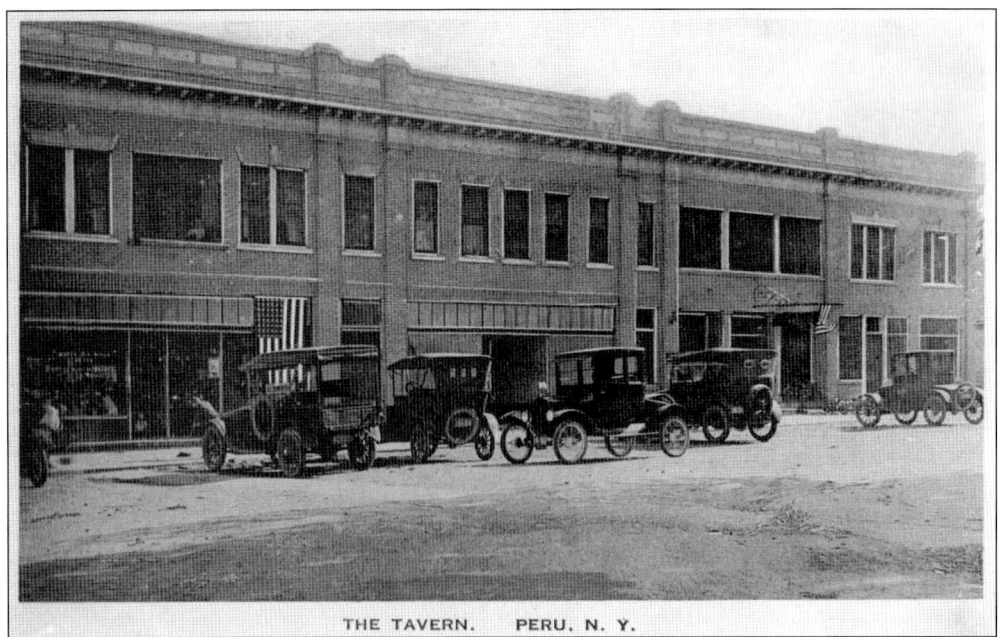

THE TAVERN. PERU, N. Y.

Henry Hebert described working at a dry goods store in Peru around 1917, saying, "Realize that downtown Peru was a very busy place at this time. Some people had automobiles, but many traveled by horse-and-buggy, or buckboard. Plattsburgh was quite a distance away, and most people hesitated to make such a long journey for groceries, dry goods, cattle feed, and the likes of such." At least part of the bustle occurred on this block of Main Street, which variously included a general mercantile, a pharmacy, a Standard Oil Company of New York office, and the tavern, which looked across the mill pond to the tannery. Part of this block was destroyed by a 1965 fire; the rest was torn down to allow for the construction of a new bridge across the Little Au Sable River. (Above, courtesy of the Cole Collection, Plattsburgh Public Library.)

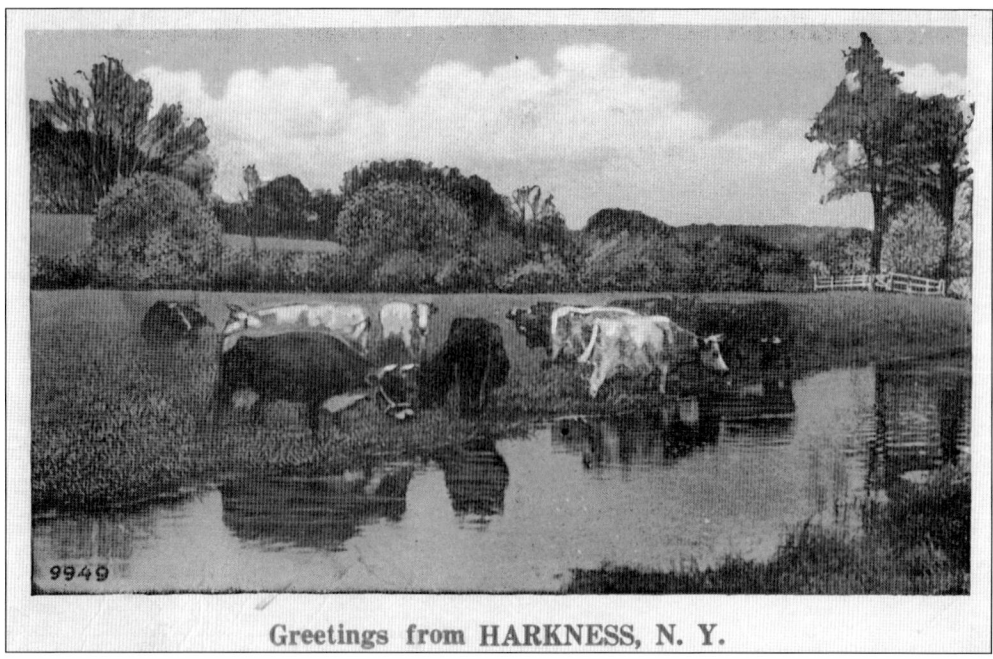

Greetings from HARKNESS, N. Y.

Part of the town of Au Sable, Harkness lies five miles northwest of Keeseville, five miles southwest of Peru, five miles north of Clintonville, and nine miles northeast of Au Sable Forks. The hamlet was named for Nehemiah Harkness, who was born and lived on a farm here. Principally a rural area, the hamlet featured dairy farms, as this postcard indicates. (Courtesy of the Cole Collection, Plattsburgh Public Library.)

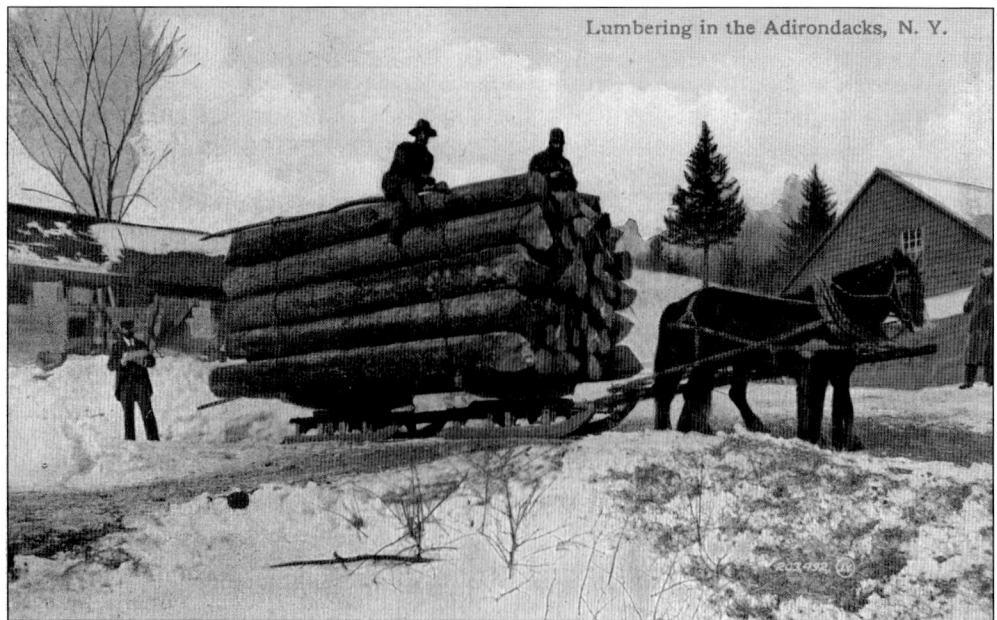

A high European demand for potash and pearlash made wood a precious commodity in Clinton County. Farmers clearing their land were able to burn the logs to create and sell potash. Later, as the demand for processed lumber increased, lumber mills and sawmills became increasingly important in the county, serving as a means to transform logs into more profitable lumber.

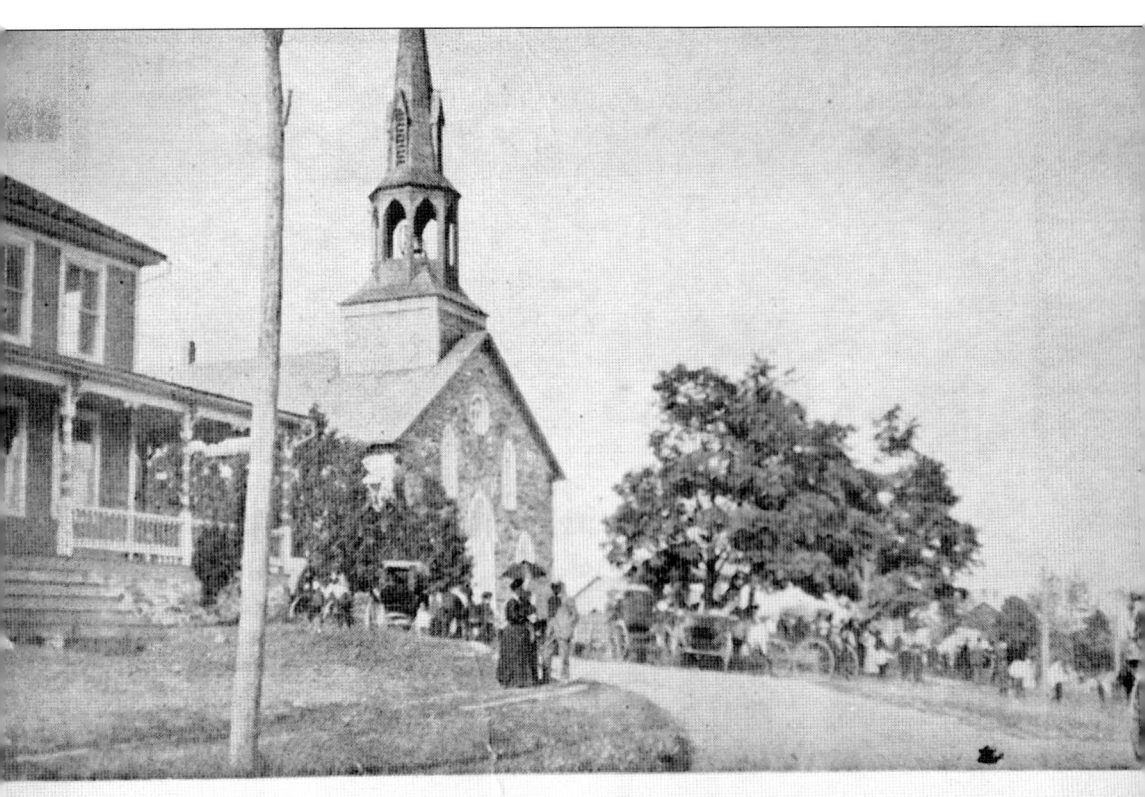

Assumption R. C. Church, Redford, N. Y., Aug. 1907.

Now part of the Catholic community of Redford and Dannemora, the Church of the Assumption is located on Center Street in Redford, on land that was deeded from Peter and Elizabeth Trombly to Bishop John McCloskey on January 10, 1854. Father J.P. Bernard laid the cornerstone for the parish on July 10, 1854, and Father Claude Sallaz blessed the completed church on August 15, 1855. Each year, the Redford Picnic celebrates this event.

First settled in 1802, the Town of Saranac was chartered by the State of New York in 1824. Included among its hamlets and villages are Clayburg, Dannemora (another part of the village lies within the town of Dannemora), Elsinore, High Bank, Morrisonville (part of which also lies in Schuyler Falls), Pickets Corners, Redford, Russia, Saranac, Saranac Hollow, and Standish. Relying on the Saranac River for transportation, log drives, water-powered industry, electric power, and recreation, the town of Saranac is most known for the glass created by the Redford Crown Glass Works during the 1800s and for the iron ore mined throughout the town. Despite that industrial heritage, Saranac also boasts a variety of farms, which started with dairy and potato farms and evolved to include beef cattle, draft horses, sheep, pigs, poultry, llama, and deer farms. The Redford Picnic is one of the town's annual celebrations. The Saranac Fiddlers and Hill and Hollow Music provide regular musical performances for the town, using the Church of the Assumption gym and United Methodist Church, respectively.

Schuyler Falls, first settled in 1794 and officially chartered as a town in 1848, has long used its rivers to power mills. In fact, the town's first sawmill was owned and operated by Ezra Turner, the first settler. The Saranac and Salmon River were later put to use creating power. The April 13, 1927, *Malone Farmer* reported, "It is understood that the International Paper Company pulp mill at Cadyville and Morrisonville together with their land in Saranac and Plattsburgh are soon to be converted into Hydro-Electric plants for the purpose of manufacturing hydro-electric power." Under previous agreements reached through the New York State Public Service Commission, much of that power was to be used by surrounding towns.

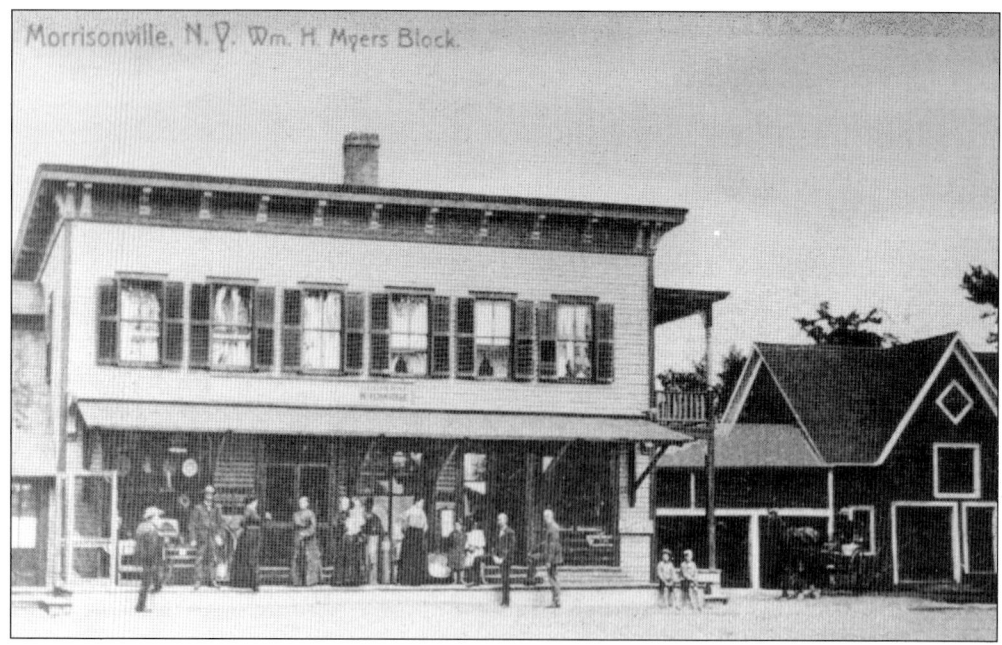

Located on Main Street in Morrisonville, the William H. Myers Block included a store. Within a short distance, visitors to Morrisonville, which lies partially in each of the towns of Schuyler Falls and Saranac, could find St. Alexander's Roman Catholic Church, the post office, the fire department, a butter factory, the school, a couple of Methodist churches, and a few additional small stores. (Courtesy of the Ron Venne Collection, used with the permission of his family.)

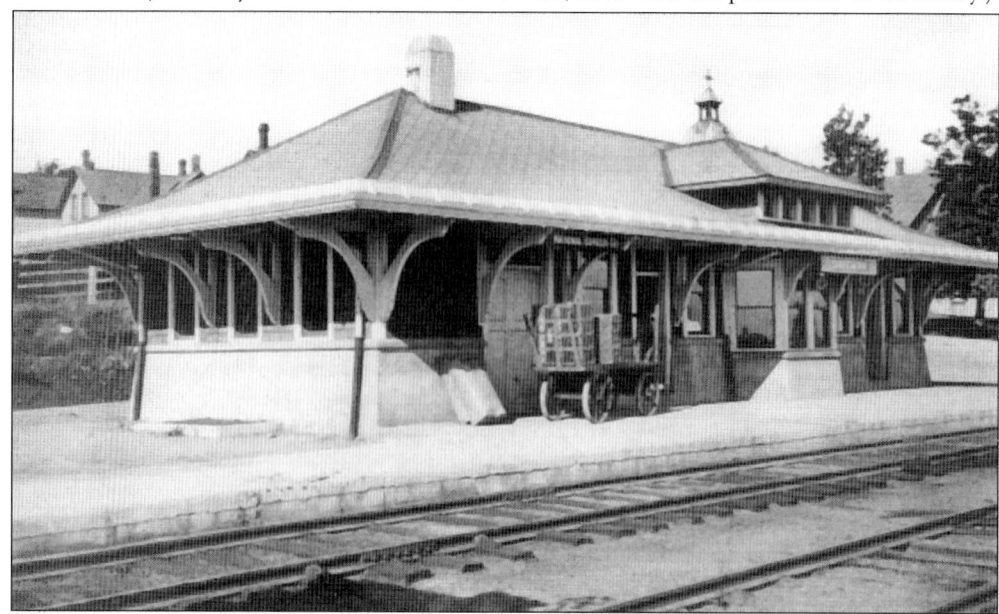

Part of the Old Military Tract, Dannemora was settled in 1836 and officially chartered in 1854. St. John B.L. Skinner, who along with F.L.C. Sailly and C.W. Averill owned the iron mines on which Clinton Prison was built, named the area for a mining region of Sweden. The Delaware and Hudson Railroad station pictured here was one of many stops on the railroad's network through Clinton County.

Cook Street, Warden's Residence on left. Dannemora, N. Y.

Named for Ransom Cook, the man who planned the prison, Cook Street serves as Dannemora's main street. This image shows the warden's residence to the left. Remembered for its beautiful flowers and water fountain that seemed to dance "as various colored lights changed the shooting streams of water into a beautiful display," as described by Terrance Gilroy in *The Village People of Dannemora*, a garden sat to the west of the warden's residence from 1931 to 1939. (Courtesy of the Ron Venne Collection, used with the permission of his family.)

Bird's-Eye View of Clinton Prison. Dannemora, N. Y.

The first buildings at the Clinton Correctional Facility, generally known as "Dannemora Prison," were built in 1844–1845 under the supervision of Ransom Cook, by prisoners who had been transported north from Sing Sing and Auburn Prisons. Designed to hold 500 prisoners, Dannemora eventually became the largest maximum-security facility within the New York State Corrections system and the largest employer in Clinton County.

Prisoner-Built Church of The Good Thief, Clinton Prison, Dannemora, New York

Dedicated on August 28, 1941, and named for St. Dismas the Good Thief, Patron of the Condemned, this church stands within the walls of the Clinton Correctional Facility. The 52-foot-by-150-foot building is topped with a gable roof clad in slate. A 106-foot engaged tower, with corner buttresses and an octagonal spire, is attached to the church. St. Dismas was the dream of Fr. Ambrose R. Hyland, who was the prison chaplain. The church was built by inmates and funded by donations. Inmate-artist Carmello Soraci created the mural pictured here, as well as the church's stained glass windows. In 1991, the church was listed in the National Register of Historic Places. (Courtesy of Dick Lynch.)

Though the school was established earlier, the University of the State of New York, High School Department, granted the Dannemora Union School the charter to teach students through their first two years of high school on December 19, 1901. Later, in 1925, the State of New York expanded that charter to include the third and fourth years of school, allowing local students to complete their educations closer to home. Students who wanted to complete their final two years of school often traveled by train to Plattsburgh. Eventually, the wood school pictured here was replaced by a brick structure. In July 1988, after almost two decades of resisting annexation, the Dannemora Union High School, as well as Dannemora's other schools, became part of the Saranac Central School District. One of the other schools annexed by Saranac was the Dannemora Elementary School, which has become the Village of Dannemora's offices. Additional space in the building houses the Dannemora Village Court, the New York State Police, the Dannemora Village Library, a museum dedicated to the village's history, and the Northern New York American-Canadian Genealogical Society.

A company town, Lyon Mountain's store and houses were owned by the Chateaugay Ore Company, later known as the Chateaugay Ore and Iron Company. Also owned by the company were some 63,000 acres of land, including a 2,600-foot vein of iron that allowed miners to raise 800 tons of ore daily from the 40,000-foot working surface. Lyon Mountain's population grew to 3,000 people because of the availability of work in the mines. Today, that mining history is commemorated by the Friends of Lyon Mountain Mining and Railroad Museum, which is housed in the Lyon Mountain Delaware and Hudson Railroad station, currently being restored to its 1903 state. (Below, courtesy of the Cole Collection, Plattsburgh Public Library.)

Settled first in 1803, the town of Ellenburg was chartered in 1830. The town was named for Ellen Murray, the oldest daughter of Harriet Murray, who, according to Myra Magoon White in *History of the Town of Ellenburg*, "had given homesteads to settlers in Township 5 of the Old Military Tract in 1823. Mrs. Murray owned much of Township 5 and the local people called the area Ellenburg to show their gratitude." (Courtesy of RuthAnn LaBombard.)

Maple Grove Creamery operated in Ellenburg Center, a "bustling location in Clinton County's dairy industry," as stated in *Clinton County: A Pictorial History*. Throughout the county, dairy farms were abundant in the second half of the 19th century. Collectively, they produced more than 1 million pounds of butter each year and more than 23,000 pounds of cheese by the early 1870s. (Courtesy of RuthAnn LaBombard.)

The Knapp Block is located on the corner of Champlain and Main Streets in Mooers. Named for Abel Knapp, who owned the first store in this building, the block is most famous for the Monette Furniture Store (on the northwest side of the corner). Purchased by Leeward Monette in 1949 and remodeled in 1960, the store served generations of local residents, remaining open into the 21st century. (Courtesy of the Ron Venne Collection, used with the permission of his family.)

Although settled around 1796, the town of Mooers was not chartered by the State of New York until 1804. Early settlers like Joshua Bosworth, the Churchill brothers, John Shedden, Ezekiel Steel, Charles Allen, and the Hagar family helped establish the town and its various communities, which have included Angellville, Cannon Corners, Mooers-upon-the-Chazy, Mooers Forks (known as Centreville until 1850), Twin Bridges, Whitney Corners, and Wood's Falls. (Courtesy of the Ron Venne Collection, used with the permission of his family.)

Mooer's Theatre, Mooers, N.Y.

Bennett Russell built and managed the Mooers Theatre, located on Route 11. The theater offered movies as well as live performances. Notably, the senior class of the Mooers Central School presented *To Kill a Mockingbird* on this stage in 1964, the year that the theater was closed. After 16 years in business, Russell sold the building to the Metal Shapes Company. (Courtesy of Dick Lynch.)

GREETINGS FROM SCIOTA, N. Y.

Winter weather often affects the ease of travel. In December 1942, Sciota witnessed that seasonal trouble when icy roads prevented the Greyhound bus from arriving in Plattsburgh on schedule. Upon reaching Sciota late in the evening, the bus experienced motor problems and had to be towed some 15 miles to the city by a local truck operator.

This picture is Sheldon's;
When you wish **him** to see,
He hangs out near the station;
In far-famed West Chazy.

"Old Shel" is the feller
Who will furnish a roof
For your building; and your cellar
Will make water-proof.

His Paroid Roofing
And Northampton Cement
Are the **best** in their lines;
Or don't cost you a cent.

Owned by and named for Lyman Sheldon, Sheldon Crossing was located on the line between Ellenburg and Chazy, an area that is now in the town of Altona. The freight station was used to unload supplies to be delivered to Dannemora Prison and to load kegs of the nails made at the prison for delivery to buyers. The station was later renamed "Dannemora Crossing." (Courtesy of Bob Cheeseman.)

School Building, West Chazy, New York

Wesleyan Methodist Church, West Chazy, New York

The brick school pictured here was built in 1832 for $360, including the price of the lot. The school's interior contained "two rows of writing tables on each side and two rows on the east end with a desk in the center of that end and an aisle 18 inches wide next to the wall," according to Nell Sullivan and David Martin's *A History of Chazy*. Ninety-two students attended this school, which "stood immediately south of the West Chazy Methodist Church." Formed in 1844, the First Wesleyan Methodist Church of West Chazy, with the Reverend Hiram McKee as pastor, met at the church of the Protestant Methodists. In 1880, the Wesleyan Methodist Church was completed. Construction on a new church building, located across the street on land once owned by Addie Goodale, began in 1914 and the old church was sold. Dedicated in October 1916, the new church was funded by Loyal L. Smith's bequest in memory of his mother. Smith provided $15,000 for the construction of a new church and parsonage and $20,000 for the maintenance of the property.

Like much of Clinton County, West Chazy lies in farm country. That fact was evidenced by the January 1916 Farm Demonstration School held throughout an entire week at Foster's Hall; Cornell University's agricultural department sponsored the extension course. Clearly a community gathering place, Foster's hosted Grange suppers, political rallies, Ladies' Social Society meetings, and plays throughout the first half of the 20th century.

West Chazy is a hamlet within the town of Chazy. Stephen Atwood, the first permanent settler in the hamlet, purchased land in 1798, cut eight acres of timber about a mile south of the village, built a log home and barn (1800), and, with his brother Joab, built the first sawmill west of the village, where the bridge crosses the Little Chazy River. East Street is shown here.

Main Street, Champlain, N. Y.

Settled in 1788, the town of Champlain is situated at the northern end of Lake Champlain. Raided by British forces in 1813, the town witnessed the beginning of what became the Battle of Plattsburgh. It has long served as a major border crossing, with stage coach routes, railroad lines, canal boat routes, and shipping paths all converging in the town. Pliny Moore, Samuel Ashmun, Elnathan Rogers, and William Beaumont were among the earliest settlers of the town, which includes the villages of Champlain and Rouses Point, as well as the hamlets of Coopersville and Perry's Mills. Catfish Point, Kings Bay, Point au Fer, Scales Point, and Twin Bridges are also located within the town. (Below, courtesy of the Ron Venne Collection, used with the permission of his family.)

Named for Samuel de Champlain, who arrived in the area now known as Quebec in 1608 and in the region now called Clinton County a year later, the town of Champlain was pivotal during the 300th and 400th anniversaries of the explorer's journeys in the "new world." Celine Racine Paquette, a village resident and the vice-chair of the New York State Quadricentennial Commission, created the Samuel de Champlain History Center to preserve the history of Champlain and promote awareness of the French settlement of the region and of Champlain's explorations on Lake Champlain. The museum is housed in a building that once served as the town library and later as the First National Bank of Champlain, a stone and brick building that overlooks the Great Chazy River. During the tercentenary celebrations, multiple events throughout the Northern Tier commemorated Champlain. Ranging from parades to speeches, pageants to postcards, the reminders of that anniversary remain constant in the county, as this relatively common postcard attests.

St. Patrick's Church, Rouses Point, N. Y. — Rev. J. Aime Troie, Pastor

St. Patrick's Roman Catholic Church is situated on Lake Street in Rouses Point. Organized in 1857, the first church was built in 1858 and named for the patron saint of Ireland. That church was closed in 1922 and demolished in 1923. A history of the new church, show here, explains: "Under the leadership of Father Cormerais, and in accordance with the wishes of Bishop Gabriels, land had been purchased on March 1, 1919 on Lake Street for $6,000 from Armand A. Ducharme. During 1922 the cornerstone for the new church was blessed. The church basement was completed in the late fall of that same year and served as a place of worship until the superstructure was finished in September 1924." Renovations to this building were completed in 1967–1968, 1988, and 1990–1991. The church's interior murals were painted by Angelo Matello. (Both, courtesy of Gary Wells.)

St. Patrick's Church, Rouses Point, N. Y. — Rev. J. Aime Troie, Pastor

Roads like this one connect Rouses Point to Champlain, Chazy, Quebec, and Vermont. The history of those places is as intertwined as the roads, which explains the Rouses Point-Champlain Historical Society's mission to "promote knowledge of the Northern Tier, its customs and its people through historically and culturally diverse programs, performances and lectures designed to broaden understanding of the Lake Champlain corridor's significance in the growth of our nation."

According to the William H. Miner Agricultural Research Institute, the Chazy farm, started in 1903, "grew from a farmhouse and a couple of barns on 144 acres into a model farm of 300 structures situated on 15,000 acres. The farm utilized a scientific approach to agriculture on a vast scale, embracing hydroelectric power and technological advances to run an enterprise that employed 800 workers in its heyday." (Courtesy of Bob Cheeseman.)

The first consolidated school in New York state, the Chazy Central Rural School was built by William H. Miner. Beyond the initial construction and subsequent expenses of the building and equipment, Miner also funded the costs of transporting students to the school. The 1920 yearbook relayed the history of the school: "To give to the children of the community all educational advantages to be obtained in any city school system . . . a building, modern in every particular and beautiful in all details was erected and opened for use on November 14, 1916. The school maintains an elementary department consisting of the eight grades, a four-year high school course, and the following special departments: Agriculture, Industrial Arts, Household Arts, Library, Music, and Physical Training. The children have also the advantage of expert medical and dental service without charge." The legacy of Miner's bequest and that larger plan for centralization continues into the present, with strong school-community ties and national accolades for strong academic performance.

THE FREEDOM TRAIN

A special exhibit train that toured the United States from 1947 to 1949, the Freedom Train visited Clinton County in 1949. Conceived as a chance to reflect on what it means to be an American and coming at a time when the United States was establishing a new and central role in world affairs, the train's journey began in Philadelphia and wound through the country, finally coming to rest in Washington, D.C., during January 1950. The July 23, 1949, *Plattsburgh Press-Republican* reported that "the Freedom Train, scheduled to arrive here late Monday night, August 1, from Malone, will, on its arrival here, be shunted to the siding parallel to Dock Street. It will remain on that site until shortly after nine o'clock Wednesday night August 3, when it will continue south to Port Henry where it will be exhibited August 4." A later train, called the American Freedom Train, toured the country in 1975–1976 to celebrate the bicentennial. (Courtesy of Gary Wells.)

Three

A Trip to the City

The Delaware and Hudson Railroad Depot sits on Bridge Street, within the city of Plattsburgh. Constructed in 1886, the depot is a red-brick, multi-story Queen Anne building. Early visitors to the region could take a horse-drawn carriage or trolley from the station to most local hotels and businesses, including the Hotel Champlain.

From the depot, visitors could take Bridge Street into the heart of downtown Plattsburgh. A large-scale painting to the right advertises the Witherill Hotel, located a couple of blocks away. The road itself leads directly to Margaret Street. Over the years, this block has included many businesses, including the O'Neil Packing Plant, which was located just out of this shot, behind the viewer and to the right.

With businesses of every type, Margaret Street has long been the busiest part of the downtown area. Restaurants, stores, banks, and doctor's offices have variously filled these buildings. Among the more famous inhabitants of the street were Merkel's Department Store, which closed in 1993; the Cady Drug Company, popular with Normal School students; Zachary's Pizza, originally Dr. William Beaumont's medical practice; and Arnie's Restaurant, still in operation.

The first mass at St. Peter's Roman Catholic Church was celebrated in 1855. Intended to serve the French-Canadian population of Plattsburgh, the church created the École St-Pierre, an academy for boys that opened in 1907, and an elementary school that opened in 1960. D'Youville Academy, also shown here, served as a boarding and day school for young women from 1860 until 1921. (Courtesy of Elizabeth Botten.)

With $50,000, Harriet Hunt Vilas created the Samuel F. Vilas Home for Aged and Infirm Women to honor her husband's memory. The home opened in 1889, with the express purpose of "the reception, boarding, relief, and care of poor and destitute women." Expansions to the red brick building, situated on the corner of Cornelia and Beekman streets, have allowed for more residents, including—since the late 20th century—men. (Courtesy of the Cole Collection, Plattsburgh Public Library.)

First located on Bailey Avenue, where the Melissa Penfield Park is now, the Clinton County Agricultural Society's fairgrounds opened in 1859. (The grandstand of the Bailey Avenue site is shown here.) The fairgrounds later moved to Boynton Avenue and, eventually, to the current location on Route 3 in Morrisonville. Gladys Deloria recalled the 1917 fair, the first for which advanced tickets were sold: "We were each given two dollars to spend and this had to last us all day. How we stretched that money to make it last! Hot dogs and rolls were twenty-five cents, soda ten cents, cotton candy, ten cents, and all the rides were a dime each. We certainly had a wonderful time." On the opening day of that year's fair, the *Plattsburgh Daily Press* proclaimed, "The Clinton County Agricultural Society has reason to feel proud of the provision it has made for the popular instruction and entertainment and the success that seems certain to be achieved this year." (Courtesy of the Ron Venne Collection, used with the permission of his family and Dick Lynch.)

PHYSICIANS HOSPITAL PLATTSBURGH, N. Y.

The first hospital in Clinton County was the post hospital, which opened in 1902. Civilian hospitals took longer to develop, with the Champlain Valley Hospital on Rugar Street opening in 1910 and the Physicians Hospital on Court Street opening in 1911. By 1926, a new Physicians Hospital, funded in large part by William T. Miner, was built on Beekman Street. Later, in 1972, the Champlain Valley Hospital (below) and the Physicians Hospital merged to form the Champlain Valley Physicians Hospital (CVPH). The CVPH continues to operate on the Beekman Street site, though medical office buildings, laboratories, and an oncology center have been added.

When the State University of New York (SUNY) system was established in 1948, the Plattsburgh State Normal and Training School was renamed SUNY Plattsburgh. Many of the buildings shown here were built during the 1960s and 1970s, when rapid growth demanded dormitories, a library, a college center, and lecture halls. Many neighborhood houses were purchased and leveled to make room for the new campus buildings. (Courtesy of the Clinton County Historian's Office.)

Saranac Hall, pictured here, served as a dining hall on Plattsburgh State University's campus until the 1980s. Named for the Saranac River, which forms the southern border of the campus and runs behind this building, the hall has continued to be a service building, housing the college bookstore, as well as the telecommunications department. (Courtesy of Elizabeth Botten.)

The Plattsburgh Normal and Training School opened in 1889 with the express purpose of training future teachers. In January 1929, the Romanesque building burned and classes were moved to Plattsburgh City Hall. A Tudor style stone building, completed in 1932, replaced the Normal School and in 1955 was renamed Hawkins Hall to honor Dr. George Hawkins, who had served as a principal of the Normal School. With the advent of the State University of New York system in 1948, Hawkins Hall became one of the many buildings on Plattsburgh State University's campus. In addition to classrooms, the hall includes the E. Glenn Giltz Auditorium, Krinovitz Auditorium, and various offices, including that of the college president.

BROAD STREET, PLATTSBURGH. N.Y.

In the past, Broad Street was principally a residential area. However, the street has also been home to Brown Funeral Home, which moved to 29 Broad Street in 1910; the Home of the Friendless, an orphanage that opened in 1897; Plattsburgh's Stafford Middle School, which sits on the lot formerly occupied by the city's junior and senior high school; several fraternities and sororities; and college buildings including Hudson and Beaumont Halls.

St. John's Parish began in 1842 and, at that time, included both Irish and French-Canadian Catholic families. After St. Peter's Church was built, the mostly Irish parishioners of St. John's decided to construct their own church, laying the cornerstone in 1869 and dedicating the building in 1875. Stained glass windows were added in 1901 and a rectory in 1908.

60

Known for its arching oak trees, destroyed by Dutch Elm disease in the 20th century, Oak Street mixes businesses with residential areas. This image centers on the Plattsburgh High School, built in 1875 on the site of the Plattsburgh Academy, which opened in 1811 and burned down in 1871. When the high school moved to Broad Street, the building became the home of the Plattsburgh Public Library.

Close to the old and new court buildings for the county, Clinton Street has long boasted an abundance of lawyers' offices. As well, the New York State Supreme Court Library for the Fourth Judicial District is located on the corner of Oak and Clinton Streets, in the building originally constructed in 1885 to house the headquarters of the Chateaugay Ore and Iron Company.

In 1898, Philip Blair opened the Monopole on Protection Street, which runs parallel to Clinton Street. The "oldest commercial enterprise in Plattsburgh continuously operated under the same name," according to Richard Frost, the bar has been a perennial favorite with local college students. Even visiting dignitaries, most notably Theodore Roosevelt, have stopped in for a drink. (Courtesy of the Ron Venne Collection, used with the permission of his family.)

The Clinton County Courthouse, pictured here, opened in 1889 on the site next to the 1884 County Surrogate Building. In 1974, a new government center was built behind these two structures and within the block bordered by Margaret (from which this view was taken), Court, Oak, and Cornelia Streets. That new building came to house the courts and other administrative offices, while still other governmental offices moved into these buildings.

Crossing from City Hall Place to Beekman Street, Court Street moves in the direction of the former Plattsburgh Normal School. Students attending Plattsburgh High School on Oak Street would have been able to look up the street to see the next step on their educational journey. A prosperous neighborhood, the street boasts many large residences, most of which were divided into apartments or offices in the 20th century.

The Brothers of Christian Instruction ran Mount Assumption Institute from 1923 until it merged with St. John's to create Seton Catholic School in 1989. Built around the Vilas Mansion, an expansion project in 1954 further enlarged the building; in 1976, the school admitted women for the first time. When Seton moved to the former Air Force base, the building was renovated to create an affordable-housing complex called Catherine Gardens. (Courtesy of Elizabeth Botten.)

TRINITY PARK

Nestled between City Hall Place (a portion of Route 9), Trinity Place, Margaret Street, and Court Street, Trinity Park serves as a meeting place for local residents, a staging area for the annual Battle of Plattsburgh Commemoration and Mayor's Cup festivities, and a place to kick back and listen to live music. This view of the park includes a fountain that was removed in 1950 to make room for a monument to honor Clinton County residents who died in World Wars I and II. Built by the Clinton County Gold Star Mothers, the monument now includes plaques to honor those who died in Korea and Vietnam. Also visible here are Plattsburgh City Hall (left) and the MacDonough Monument. The County Court and Surrogate Building are to the viewer's back. During the 19th century, visitors to this park would have been within an easy walk of the Cumberland and Witherill Hotels, as well as the Plattsburgh Theatre and Clinton Hall.

CITY HALL

John Russell Pope, a Columbia University–educated architect who won the McKim Travelling Fellowship and the first prize awarded by the American School of Architecture in Rome, designed Plattsburgh's city hall. A neoclassical building, Plattsburgh City Hall—built in 1917–1918 and largely funded by a bequest made by local philanthropist Loyal B. Smith—was listed in the National Register of Historic Places in 1973.

Trinity Church, shown to the left of a local bank and situated across the street from the old federal courthouse, was built of blue limestone in 1830. Consecrated in 1831, the church expanded in 1852, added stained glass windows in 1866, and replaced the wooden spire with a stone tower in the 1930s. Further additions include a rectory made of Bluff Point stone (1907) and Trinity Memorial Hall (1962).

20 New Cumberland Hotel and Plattsburgh Theatre in distance, Plattsburgh, N. Y.

The Plattsburgh Theatre, situated behind the Cumberland Hotel in the Weed Building on the corner of Court and Marion Streets, was considered the "community's grandest auditorium," according to the *Plattsburgh Daily Republican*. With 1,002 seats, the theater hosted a variety of events. The famous orator William Jennings Bryan spoke here. Plattsburgh High School's graduation ceremonies were held here from 1893 until 1924. Additionally, moving pictures—with a live orchestra in attendance for evening shows—were shown and stage acts performed here. On September 10, 1923, for example, George McManus's "Celebrated Musical Comedy Cartoon 'Bringing Up Father on Broadway' " offered two acts, six scenes, "lavish scenic investiture," 30 people ("mostly girls"), and 25 musical numbers, with ticket prices for the one-night-only showing set at $1.10, 83¢, or 55¢, tax included, as reported in the *Plattsburgh Daily Republican* of September 7. The theater advised, "It's one big laugh from start to finish. If you can't laugh at this show, see a doctor." The Plattsburgh Theatre was destroyed by a March 17, 1928, fire. (Courtesy of the Clinton County Historian's Office and Dick Lynch.)

Plattsburgh's first airport, the Mobodo Airport, was located on North Margaret Street, near Georgia Pacific's warehouses. When the airport's name changed to the Plattsburgh Airport in 1930, the owners boasted of 227 airplane landings in the summer and winter of 1929, which included landings by several prominent aviators. Later, a city bond issue proposed buying land west of the city for a new airport. When that bond passed in 1941, the Plattsburgh Airport moved to Route 3, near the Clinton County fairgrounds. That site, called the Plattsburgh Municipal Airport, included a ramp on the north side of the facility, as well as three paved runways and taxiways, all situated on an irregularly shaped 1,120-acre lot. In 2007, a new terminal was built on the former Plattsburgh Air Force Base. Making use of the existing runway system, the Plattsburgh International Airport now hosts industrial air companies, an aerospace park, and passenger airline services. (Courtesy of Gary Wells and Dick Lynch.)

KENT DELORD HOUSE, PLATTSBURG, N.Y. 44

OCCUPIED BY BRITISH OFFICERS, SEPT. 6TH TO 11TH, 1814

Built in 1797 by William Bailey, this Georgian structure was home to the Delord family, who occupied it for more than 100 years. When the last descendent of the family, Frances Hall, died, she left the building to the Physicians Hospital. William H. Miner purchased the Kent-Delord house in 1925, giving it to a memorial association that eventually formed the Kent-Delord House Museum.

PLATTSBURG HIGH SCHOOL AND JUNIOR HIGH

Situated on Broad Street, facing Margaret Street, the "new" Plattsburgh high school and junior high were dedicated in 1914. By 1965, Plattsburgh High School had moved to Rugar Street. Then, when a 1970 fire damaged this building, the Plattsburgh City School District decided to rebuild on the site. The Stafford Middle School opened here in 1976 and continues to serve the district's students.

The Pal Blade Company opened in 1933 on South River Street. The company produced 75 million razor blades a month, along with injection razors and paring knives. By 1948, Pal Blade employed 800 employees. In the late 1940s and early 1950s, Pal Blade experienced labor unrest: a 42-day strike of company workers ended on November 2, 1946, when the Local 1585, International Association of Machinists, and the company, with the assistance of the US Conciliation Service, agreed to a wage increase of 17.5¢ per hour. Pal Blade was sold to the Mailman Company in 1953 and, as the American Safety Razor Company, closed in March 1954, leaving close to 900 people unemployed. (Above, courtesy of Bob Cheeseman; below, courtesy of Beulah Laurin.)

OUR LADY OF VICTORY ACADEMY, PLATTSBURG, N. Y.

Our Lady of Victory Academy, also known as L'Académie Notre Dame des Victoires, opened in 1911 on South Catherine Street in the heart of one of Plattsburgh's two French Canadian neighborhoods, and closed in 1969. According to various advertisements in the *Plattsburgh Daily Republican* and *Plattsburgh Daily Press* throughout 1920 and 1921, the school in its early years served "young ladies and girls," offering "classic, literary and scientific courses, French receives special attention, departments of music and art." Later, the school boasted of its "modern equipment, university trained teachers, large campus, [and] large well ventilated dormitories." As time went on, the school became a "co-educational high school, a boarding school for girls, and a convalescent home for thirty ladies." A separate school, the Notre Dame Elementary School, was built on the church's property, opening in 1961 and remaining in service until 1993. Our Lady of Victory Secretarial School also operated on the grounds from 1958 until 1993, serving students from New York, Vermont, Canada, and beyond. The OLVA building is now Victory Place, an independent-living facility. (Courtesy of Dick Lynch.)

Four

AT THE BASE

United States Army Post. Plattsburg Barracks, N. Y.

Plattsburgh's military history extends back to the American Revolution, with the Battle of Valcour, and the War of 1812's Battle of Plattsburgh. However, the post was only established in 1838. Soon after, in 1839, the Old Stone Barracks were constructed and the tradition of a permanent military installation began. That history was not an easy one: closure was constantly possible until, in 1995, the Plattsburgh Air Force Base finally closed.

Although some 40 log barracks were built between Forts Brown, Moreau, Scott, Gaines, and Tompkins following the War of 1812, construction on these brick barracks, officers' quarters, and a post hospital began in the 1890s. Buildings such as these housed soldiers who trained for the Spanish-American War. Over time, additional officers' quarters, along with a quartermaster's storehouse and workshop were built.

Various officers stationed at the Plattsburgh Barracks lived in Officers' Row. In 1901, the commissioned officers at the barracks included: Col. Sanno, 18th Infantry, commanding post; Capt. Andrus; Adj. Capt. Smiley; Capt. Cronin; Capt. Shuttleworth, quartermaster and commissary; Capt. Phillips; Capt. Sturtevant; Capt. Hero; 1st Lt. Wygant; 2nd Lt. Morgan; 2nd Lt. Brown; 2nd Lt. McNamara; 2nd Lt. Loring; 2nd Lt. Jossman; 1st Lt. Page; and Dr. Richardson, post surgeon.

Battle of Plattsburgh
September 11, 1814

The Battle of Plattsburgh Association, which operates the Battle of Plattsburgh Interpretive Center and War of 1812 Museum, is located on the grounds of the former Plattsburgh Barracks and sponsors a variety of historical events related to the battle. Re-enactors, like Josh Wingler (left) and Craig Russell (right), participate in those events and remember the September 1814 battle in annual ceremonies that begin at the former Dewey's Tavern in Champlain and proceed south through Chazy, Beekmantown, and Plattsburgh. Special stops at the sites of the Culver Hill and Halsey's Corner skirmishes form part of the yearly commemoration, which is organized by a separate committee and sponsored, in part, by the City of Plattsburgh. A full-scale re-enactment of the Battle of Plattsburgh occurs as part of that commemoration, reminding local citizens and visitors to the region of the significance of the battle within the larger war and the patriotic work of students, women, children, and the elderly to defeat the British.

The Hostess House served as a welcome center for boys attending the Citizens Military Training Camps. In 1928, Publicity Officer William Slater described the work of the house, writing that the two "camp mothers" had "a multitude of duties, from advising the boys about their girls to patching up garments and writing letters for them. The hostess house is one of the most popular spots in camp." (Courtesy of Mary Starke.)

The Citizens Military Training Camp began with Major General Leonard Wood's "Plattsburgh Idea." Wood believed that ordinary citizens should be prepared for potential military service during wartime. The first camp occurred in 1915 and found great success. A later camp class explained that "To-day the world pronounces Plattsburg, as a training camp for officers, a success."

C. M. T. CAMP, PLATTSBURGH BARRACKS.

STUDENTS ON RIFLE RANGE, PLATTSBURGH, N. Y.

Included in the six weeks of intensive training was a concluding nine-day hike during which each man carried a 42-pound pack. The training was effective: an estimated 90 percent of Plattsburgers saw military service in World War I, most of them as line officers. The camps continued through the 1930s.

U. S. Fifth Infantry, Bridge St., Plattsburg, N. Y.

During the 300th anniversary of the discovery of Lake Champlain, soldiers participated in Plattsburgh Day. The Lake Champlain Tercentenary Commission reported: "One of the striking features of the exercises at this place was the brilliant military parade at Plattsburgh barracks," which included the 5th Infantry, pictured here marching on Bridge Street, as well as the 24th Infantry, a squadron of cavalry, the 2nd New York Regiment, and the Governor General's Foot Guards of Ottawa. (Courtesy of the Ron Venne Collection, used with the permission of his family.)

President Roosevelt at Plattsburgh Barracks, Plattsburgh, N.Y.

Three of Theodore Roosevelt's four sons attended the training camps at Plattsburgh, so it is not surprising that Roosevelt visited. In fact, Roosevelt, who led Maj. Gen. Leonard Wood in the Rough Riders, strongly advocated for universal military training. Other dignitaries who visited the barracks included Pres. William McKinley, along with his vice president, secretary of the interior, attorney general, and Franklin Delano Roosevelt, then governor of New York. (Courtesy of the Ron Venne Collection, used with the permission of his family.)

ARTILLERY IN ACTION. SOUVENIR 1ST ARMY MANEUVERS, PLATTSBURG, NEW YORK, 1939

During 1939, the Plattsburgh Barracks witnessed the largest peacetime maneuvers in the United States, with more than 30,000 troops participating in the First Army maneuvers. The *Plattsburgh Daily Press* reported 30 trains arriving with troops: "About 450 coaches and baggage cars were used. These cars, with the locomotives necessary, would make up one train more than seven miles in length."

LIFE IN THE BIVOUAC AREAS. SOUVENIR 1ST ARMY MANEUVERS, PLATTSBURG, NEW YORK, 1939

The *Plattsburgh Daily Press* reported difficult times for the soldiers who came for the maneuvers in 1939. "Uncle Sam's First Army," they wrote, "slithered through mud yesterday as the sharp staccato of rifle and machine gun fire and the booming of artillery echoed through these foothills of the Adirondacks and mingled with the rumbling of thunder which presaged a heavy fall of soaking rain. Last night, when the 'smoke of battle' had cleared, the weather added to the list of minor casualties." The purpose of the early maneuvers was "to test the efficiency with which advance parties could relay information to supporting troops after contacting an enemy."

COME AND GET IT. SOUVENIR 1ST ARMY MANEUVERS, PLATTSBURG, NEW YORK, 1939

OVER THE TOP. SOUVENIR 1ST ARMY MANEUVERS, PLATTSBURG, NEW YORK, 1939

Action in the 1939 First Army maneuvers continued with "a series of eleven skirmishes in which regiment opposed regiment, problems were worked out in advance and flank guard action. The plan of activity in each of the eleven 'dog fights' was identical. Setting out at the same time from 'jump off' points five or more miles apart, opposing regiments, supported by field artillery, tanks and observation planes, slowly and cautiously moved against one another," according to the *Plattsburgh Daily Press* of August 17, 1939. The skirmishes occurred around the barracks and at the Macomb Reservation State Park in Schuyler Falls. "The first firing broke out as small advance details, forming the points for the advancing columns, sighted one another . . . 'Enemy' observation planes, darting about a few hundred feet overhead, were targets for rifle fire from the ground troops."

After the 26th Infantry left Plattsburgh in 1941, the combat engineers in 1942–1943 used the barracks for training. Then, in 1944, the former barracks became the Naval Training Center, Camp MacDonough. Seamen could earn their commissions as ensigns and midshipmen during the 60-day courses held here. The first graduation ceremony, in June 1944, involved commissioning 1,900 naval officers. The US Navy deactivated the site at the beginning of 1945.

When the barracks was declared surplus property by the US Army in 1946, the State of New York purchased the property for Champlain College. Dedicated to serving World War II veterans, the college began as a two-year institution and became a four-year college within the State University System in 1948. The college closed in 1953, when the US Air Force chose to create the Plattsburgh Air Force Base on this site.

CHAPEL — CHAMPLAIN COLLEGE — PLATTSBURG, N. Y.

Now known as the Plattsburgh Memorial Chapel, this brick structure was built around 1933. With a slate roof, the Norman-style building includes two transepts for worship: one a Jewish tabernacle and the other a Catholic altar. Designed and dedicated as an interfaith, interdenominational space, the chapel memorializes soldiers who died in World War I.

CUMBERLAND HALL — CHAMPLAIN COLLEGE — PLATTSBURG, N. Y.

Cumberland Hall, part of Officers' Row during the barracks and Plattsburgh Air Force Base years, is part of the United States Oval Historic District, which was listed in the National Register of Historic Places in 1989. Once the Plattsburgh Air Force Base closed in 1995, these buildings were repurposed as offices for local businesses and agencies.

GYMNASIUM — CHAMPLAIN COLLEGE — PLATTSBURG, N. Y.

The gymnasium, pictured here when it was part of Champlain College, was also used by the Plattsburgh Air Force Base, and post–base closure, by the City of Plattsburgh Recreation Department. Built in 1934, the gym is rumored to be haunted. Each year, at Halloween, the stories resurface and local residents report strange noises.

THEATRE — CHAMPLAIN COLLEGE — PLATTSBURG, N. Y.

In May 1947, the Harlequin Club of Champlain College presented a three-act, comedy-fantasy called *Heaven Can Wait*. The play showed for three nights at this facility, located on U.S. Oval, near the gym. In 1951, the Champlain College music department used the theater for a three-night run of Gilbert and Sullivan's *The Mikado*.

TICONDEROGA HALL — CHAMPLAIN COLLEGE — PLATTSBURG, N. Y.

When the Plattsburgh Air Force Base took over the campus, Ticonderoga Hall became the administrative building for the installation. The Military Civil Engineering Department was on the first floor; the Civilian Civil Engineering Department was on the second. Deemed too difficult to maintain, the porches were removed, later to be replaced by a series of stoops. (Courtesy of the Clinton County Historian's Offices.)

On January 29, 1954, a ground-breaking ceremony inaugurated the Plattsburgh Air Force Base. Encompassing the former barracks, with an additional 3,600 acres, the base would be home to the 380th Bombardment Wing. In March 1956, the first B-47 arrived on the base; KC97s soon followed. This image shows a KC-97 Stratotanker (left) fueling a B-47 Stratojet bomber.

While the Plattsburgh Air Force Base was in operation, the Officers' Club was the site of a host of activities and ceremonies. With a seating capacity of 600, the club was the perfect site for Clyde Lewis's testimonial dinners, held twice a year to pay tribute to visiting dignitaries, high-ranking US Air Force officials, and members of the local community with special ties to the base.

Sitting on the "new" side of the base, the non-commissioned officers (NCO) club served as a recreational facility for service personnel who had been promoted from the enlisted ranks to the position of officer. The NCO club sat next to the recreation center for enlisted men. West Side Ballroom now owns the former NCO club, offering a venue for weddings, receptions, political fundraising dinners, and other events. (Courtesy of Elizabeth Botten.)

In addition to new flight facilities, construction of the base included new housing for the personnel to be stationed here. Mostly on the "new base," which sat to the west of the original barracks site, the construction included this interdenominational church. Situated nearby were the BX, the movie theatre, the recreation center, the new commissary, and two schools. The chapel is now the home of the North Country Alliance Church.

When local students were asked to create tiles to illustrate local history, they chose to re-create the Stone Barracks, the oldest building on the former Plattsburgh Air Force Base. Built in 1839, the Old Stone Barracks is the iconic image of the base and of the military history of the region.

Five

WHERE TO STAY?

The entrance to the Hotel Champlain, on Route 9 between the city of Plattsburgh and town of Peru, indicates the grandeur of the hotel. Owned by the Delaware and Hudson Railroad, the hotel sat on 1,000 acres overlooking Lake Champlain. Upon its 1890 opening, the hotel had 500 rooms, 11 cottages, a golf course, and the famed Singing Sands Beach. Additional rooms and cottages were built in the next five years. (Courtesy of the Ron Venne Collection, used with the permission of his family.)

According to Herman Doh, "The reputation of the Hotel Champlain as the finest of summer resorts was firmly established by 1917. At the beginning of the season, the Hotel announced that the cottages were all rented, that some guests would arrive in private yachts, and that Astors, Vanderbilts, and other members of the 400 were booked for various times during the season. And—President McKinley would spend August at the Hotel." When the original hotel burned in 1910, cottages like this one continued to operate, though at a greatly reduced level of occupancy. By July 1911, the new hotel building was complete and the Hotel Champlain was able to resume its normal summer business.

Located two miles north of Plattsburgh, the Elmhurst Inn was known for its "excellent chicken dinners." Owned by John D. Martin, the inn advertised a garage in addition to its specialty foods. In December 1928, when the Dairymen's League Association met at the inn, the *Plattsburgh Sentinel* reported that "a delicious dinner was served the gathering by the management of Elmhurst Inn at noon."

Maj. William T. Howell purchased the Witherill Hotel in 1884 and opened the Margaret Street hotel in 1886. After World War II, Howell turned the hotel over to his son, William H., who ran the hotel until it closed in 1967. The Witherill Hotel offered some of the finest accommodations in Clinton County and used postcard booklets to remind travelers to return.

A postcard booklet depicts the Witherill Hotel in this fashion: "the comfortable homelike atmosphere is enhanced by the attractive furnishings, the spotless housekeeping and the renown of its cuisine. Every modern convenience is provided: telephone in each room, elevator service, room service and all the other services found in a metropolitan hotel." (Courtesy of Gary Wells.)

Described on the postcard as a "private dining room, a richly furnished, homelike room for small, intimate dinner parties," the Heppelwhite Room served both visitors and locals. The foundation of the Plattsburgh Rotary was laid here, when a group of men met "to form a local organization for community service, social activities and some good times," according to the the *Plattsburgh Press Republican* of April 23, 1976. The Plattsburgh Kiwanis also used the facilities, notably for its Christmas parties for local children. (Courtesy of Gary Wells.)

Guests stayed in rooms like these while at the Witherill Hotel. The private apartments (top), were "magnificently furnished with priceless antiques," while the typical guest rooms were "spacious, airy, smartly furnished, delightfully comfortable," as described on the postcard. In a 1974 presentation, William H. Howell Jr., grandson of the man who opened the Witherill, said: "The prominent guests at the Witherill Hotel were too numerous to name but among them were United States presidents, governors of New York, army generals, admirals, senators and celebrities." He specifically recalled, "the sojourn of a movie production company in 1928 shooting winter scenes in the Plattsburgh area for the movie 'Uncle Tom's Cabin.'" (Both, courtesy of Gary Wells.)

A booklet of Witherill Hotel postcards labels this image: "Part of the staff . . . this splendid organization is dedicated to making your stay at the Witherill a delightful experience." Within the region, hotel staff and guests often fell into very different economic classes. Many of the people pictured here probably lived outside of the city, commuting at a time when the trip was expensive and not very easy. Johanna Luisi, who lived in Morrisonville in the early 1900s, recalls, "Papa worked hard as a painter and decorator in a big hotel in the city, and traveled two hours back and forth to work on a train." The names and roles of these people are largely absent from the historical record, though the local paper did note one Witherill employee's stay in a Montreal hospital when, in 1933, Guido Canala was admitted to see an eye specialist. At some hotels, notably the Hotel Champlain, race was also an issue, with Caucasian guests being served by African American staff members. (Courtesy of Gary Wells.)

In 1922, the Adirondack Hotel, located in Dannemora, was destroyed by a fire. Forty convicts from Clinton Prison fought the fire, working with local citizens to keep the blaze from spreading to surrounding properties. At various times, the four-story frame structure was owned by Robert Dean, Jefferson Robert, and—when this postcard was printed—J.S. Meader and Son.

The Fairview House in Ellenburg Depot was owned by Dave Smith and later run by Robert Bell. In addition to offering accommodations, the hotel hosted various sales of ladies' and misses' suits, jackets, separate skirts, raincoats, and carpets for Nathan Frank's Sons, Ogdensburg's "largest Dry Goods Store and Cloak House."

Throughout Clinton County, small farms and personal homes were converted to tourist houses, open to passing motorists seeking a place to eat and sleep. Pardy's was one such small inn. Located in Chazy, the inn offered home-like service for guests who did not want to stay in larger hotels like the Witherill or Savoy. Unlike the larger hotels, smaller inns and bed-and-breakfasts offered fewer amenities like private bathing facilities and fancy entertainment. However, travelers were generally able to take their meals, or at least breakfast, with the homeowners, and they were much closer to the country vistas, walks, and fishing holes for which the county is noted. The practice of welcoming travelers into a home dates back to the beginnings of the United States, with increases in rail and automobile travel prompting the construction of larger, more centralized hotels. During the 1980s, this tradition reappeared with a surge in bed-and-breakfasts throughout the nation. Interestingly, "Aunt Mamie" has very little to say about the accommodations on this postcard. (Above, courtesy of Gary Wells; below, courtesy of the Cole Collection, Plattsburgh Public Library.)

The Windsor, located in Rouses Point on the banks of Lake Champlain, was built in the 1890s as "an elegant summer resort," as described by the *Plattsburgh Press Republican*. With 100 rooms, many with private baths and hot and cold running water, the Windsor's rates began at $2 a night. Later, the Windsor became the Saxony, a hotel whose bar and dance floor attracted visitors from northern New York and Vermont. (Courtesy of the Ron Venne Collection, used with the permission of his family.)

In 1966, the Anchorage Motor Inn, owned by the Bosley family, was cited by the Travelmats Corporation of America as "one of the outstanding traveler stops in this part of the country." The original wooden hotel burned down on May 29, 1990. Now, the Anchorage—still located on Lake Street in Rouses Point—consists of smaller motel units located in the back of this lot. (Courtesy of the Ron Venne Collection, used with the permission of his family.)

According to the Lake Champlain Maritime Museum, "By 1833, there were 232 cargo- and passenger-carrying canal boats registered at towns along Lake Champlain and the canal." Rouses Point and Champlain numbered among those towns, with Champlain even entering into the business of building canal boats. For the families who lived and worked on the boats, the preponderance of larger boats on the lake made the canal boats seem precarious.

Located half a mile from Champlain, the Manoir Hotel was owned by George Laurendeau. Advertisements for the hotel suggest that visitors should "come and have a good time at the Manoir Hotel . . . All the comforts and pleasures of a Canadian Hotel." Music, provided by a "first class orchestra," and dancing, along with chicken and steak dinners, were specialties of the house. (Courtesy of Bob Cheeseman.)

The Tourist Garden Hotel, formerly known as the Manoir Hotel, was owned by George Laurendeau and Gervais Bissonetto. In 1930, when Laurendau took over the management of the Tourist Garden Hotel, he planned on making it "one of the most popular resorts in Canada." Though it is situated just across the border from Champlain, the hotel was considered a local entity. (Courtesy of Bob Cheeseman.)

Purdy's Hotel (right) was situated next to the Scriver Block on Main Street in Mooers. In the building's earlier years, John Sheppard Sheddon ran a store here. Later, in early 1902, the Bible House, a residential religious school, opened in this building. When New York state developed Route 22, these buildings were torn down.

Plattsburgh, N.Y., Depot and Foquet House.

Located on the corner of Bridge and MacDonough Streets, the original hotel on this site—the MacDonough House—burned down in 1864. The hotel was replaced with the Foquet House, built in 1865 by John L. Fouquet and situated diagonally across Bridge Street from the Delaware and Hudson Railroad Depot. The four story building, with a mansard roof, hosted Pres. Grover Cleveland in 1885, Benjamin Harrison in 1892, and innumerable parties, Fourth of July dances, and formal gatherings throughout its existence. Allan Everest explained that the hotel "passed through several hands, including those of Paul Smith of Adirondack innkeeping fame. In the 20th century it became the headquarters of the M.P. Myers Company." When 55 members of the Laurel Fire Company of York, Pennsylvania, and the Liberty Band of Middletown, New York, visited the area in 1922, they were entertained at the Horicon Club on Margaret Street and then escorted to the Foquet House, possibly Plattsburgh's most famous hotel. The group spent the night at the hotel and departed the next morning by boat to travel through Lake Champlain and Lake George.

Normal Court Inn, 116 Court Street. Plattsburgh, N. Y.

Also known as the College Court, the Normal Court Inn was previously the Physicians' Hospital and later a dormitory for local college students. Before Plattsburgh State University's residence halls were built, the college contracted with several small inns to provide accommodation for students. At the Normal Court Inn, the Kimball family "served as live-in houseparents, enforcing the administration's firm rules for acceptable student behavior." (Courtesy of Darlene Winterkorn.)

NEW CUMBERLAND HOTEL, PLATTSBURG, N. Y.

Before the Cumberland Hotel was built on the corner of Margaret and Court Streets, the lot was occupied by the Phoenix, a hotel kept by John McKee. In 1937, the hotel advertised a "delicious ten-course New Year's dinner for $1.25. Why waste your time cooking and serving—let us do the worrying. Call 214 for reservations." A 1978 fire destroyed the hotel; a parking lot now stands in its place.

In 1920, the Union Hotel advertised a $1 Sunday dinner that included chicken soup, celery, radishes, macaroni and cheese, roast turkey, sage dressing, giblet sauce, mashed potatoes, fresh asparagus on toast, with butter sauce, and, for dessert, apple pie and wild strawberry shortcake. By 1958, that $1 lunch special included only roast turkey and dressing, served with mashed potato and corn. A 1969 ad welcoming college students back to Plattsburgh merely suggests stopping in "for a drink and fine music." The Union Hotel—and its lounge and bar—was popular with students at Champlain College and at Plattsburgh State University. That popularity was evident in a 1997 *Press Republican* editorial that recalled, "The old Union Hotel was headquarters, from which youthful inebriation would scatter to sample the alcoholic offerings through the downtown" on St. Patrick's day. When Plattsburgh students protested the bombings of Cambodia and the harbors of North Vietnam in 1969, their march carried them down Broad Street, past the Union Hotel (on Margaret Street), to the MacDonough Monument, where a peaceful vigil was held. (Courtesy of the Ron Venne Collection, used with the permission of his family.)

CATHOLIC SUMMER SCHOOL, CLIFF HAVEN, N. Y. NEAR PLATTSBURG, N. Y.

Chartered by the Regents of the State of New York on February 9, 1893, the Catholic Summer School was part of the Catholic Chautauqua movement. When the Delaware and Hudson Railroad donated 400 acres in 1896, the school moved to Cliff Haven, where parishes from around the country built cottages for vacationers. The Catholic Summer School had a chapel, a casino, a clubhouse, boarding houses, tennis courts, and a nine-hole golf course. The cottages, which were quite simple or quite elegant, cost upwards of $1 a week. An orchestra played during the Sunday dinner and three other days a week; formal dances were held on Wednesdays.

CATHOLIC SUMMER SCHOOL, CLIFF HAVEN, NEW YORK.

54 VALCOUR COTTAGE (PRIVATE).

CATHOLIC SUMMER SCHOOL, CLIFF HAVEN, NEW YORK.

17 VIEW FROM CHAMPLAIN CLUB TO ALUMNAE, LOUGHLIN COTTAGE.

Though its curriculum included astronomy, art, music, philosophy, literature, French, and physical culture courses, the Catholic Summer School also encouraged swimming, tennis, golf, cycling, mountain climbing, and boating. Located in close proximity to various Route 9 lodgings, many of the school's activities included visitors from the Hotel Champlain and the Plattsburgh Barracks. In 1904, the property, which included a house, farm, 400 acres, and the buildings of the school, was assessed at a value of $75,000. (In the same year, Plattsburgh High School, located on Oak Street, was assessed at only $35,500.) The Catholic Summer School continued to thrive until the 1930s, after which the facilities were demolished to make way for the Cliff Haven housing development.

The Lake Drive at Cliff Haven, N.Y.

Six

ON THE WATERFRONT

One of the great attractions of the Cliff Haven site for the Catholic Summer School, pictured here from the lake, is its proximity to Lake Champlain. About 130 miles long, the lake lies partly in New York, partly in Vermont, and partly in Canada. Residents of that larger Champlain region share a common heritage, often based on the commerce, transportation, and activities developed because of the all-important waterway.

An 1897 *New York Times* article referred to Bluff Point—with the Hotel Champlain and its famous Singing Sands Beach, seen here—as "one of the most strikingly picturesque resorts to be found anywhere. It has both the charm of wildness and the restful attractiveness of careful and artistic adornment. Here are expensive grassy lawns, delightful groves, and inviting beaches, where the music of the 'singing sands' is heard." In fact, the same article offered the notion that "the 'singing sands' of Lake Champlain have imparted a romantic interest to the hard, white, sloping beaches of this majestic lake. Here is a picturesque body of water that fills a valley inclosed by lofty mountains." The famed Seneca Ray Stoddard photographed the beach, which was the site of many Hotel Champlain activities. In the early 1980s, after Clinton Community College was established on the site of the former hotel, the beach property was converted to 22 townhouses. (Courtesy of the Ron Venne Collection, used with the permission of his family.)

A 40-acre island in Lake Champlain, Crab Island was used as a military field hospital during the Battle of Plattsburgh. In 1908, the Crab Island Soldiers and Sailors Monument, the granite obelisk pictured here, was erected on the island to honor the Americans who died and were buried there. In 1988, New York state took over the island via eminent domain.

Bluff Point is located south of Plattsburgh, near Clinton Community College. The rock ledge looks over Lake Champlain to the western side of Valcour Island, where the Bluff Point Lighthouse is located. Placed in service in 1874, the lighthouse guided sailors through the narrow passageway between island and shore for almost 60 years. Although the lighthouse was taken out of service in 1930, it was reactivated in 2004.

Old Keeseville Tales, a history of the village and its inhabitants, explains that, "The wonderful water power of the Au Sable river seems to have been the magnet which first attracted the pioneers of those early days, and we read that a certain Captain Jonathan Bigelow, about the year 1806 or 1807, foreseeing, with Yankee shrewdness, that the valley was a promising location for manufacturing interests, decided to erect a saw mill on the rapids, just above the lower bridge." Later settlers were also enamored of the river's power. A variety of mills were built along the Au Sable, including the Au Sable Horse Nail Company, which now houses the Adirondack Architectural Heritage offices. That bridge, built by the towns of Au Sable and Chesterfield and extending 110 feet, is the longest single-span, keystone-arch bridge in America. (Above, courtesy of the Ron Venne Collection, used with the permission of his family.)

On the Clinton-Essex county line, a dam built by McGrath Industries called the Alice Falls Hydro Project rests on the waterfall known as Alice Falls. A New York State Conservation Commission report from the early part of the 20th century indicates that, "At Alice Falls the water is diverted into a headrace by a masonry dam and a head of 47 feet is obtained on a wheel installation of 2,000 horsepower." (Courtesy of the Ron Venne Collection, used with the permission of his family.)

Twin Bays, located on Valcour Island, is a prime camping site in Clinton County. Visitors cross to the island via boat and establish a camp on a first-come, first-served basis. The island, which is the fourth largest on Lake Champlain, has many day sites, camping sites, and bird sanctuaries. (Courtesy of the Cole Collection, Plattsburgh Public Library.)

The views of the Hotel Champlain from the lake and of Lake Champlain from the hotel illustrate why the resort was so popular. The lake provided a means for entertainment and transportation, as well as endlessly beautiful sights. Although the Hotel Champlain and Clinton Community College most notably occupied this site, its history extends a bit further: the Delaware and Hudson Railroad sold the site to the Mailman Brothers, who owned the Pal Blade Company, in 1939; they, in turn, sold it to the Jesuits, who operated the site from 1951 to 1967. Undoubtedly, the Jesuit seminarians at the Bellarmine Novitiate enjoyed the view as much as they are said to have appreciated the proximity to the Bluff Point golf course.

Originally intended for the county's offices, this site was later determined to be too far away to be practical. Thus, Clinton Community College began operations in 1969. By 1971, Clinton County decided to purchase the buildings and 100 acres for the college, which now thrives, offering AA, AS, and AAS programs and working within the State University of New York system of colleges and universities.

The Salmon River travels from Schuyler Falls to Lake Champlain. During the late 19th and early 20th centuries, a settlement formed around the river. Falling between the current Irish Settlement and Salmon River Roads and situated on Route 22, the community included a church, farms, and a store owned by Archie Bourdeau, for whom a nearby road was named.

MOONLIGHT ON LAKE CHAMPLAIN NEAR PLATTSBURGH N Y

Lake Champlain's vistas inspire fond memories and loyalty, as evidenced by this 1837 poem by Margaret Miller Davison: "That dear old home, where pass'd my childhood's years, / Where fond affection wiped my infant tears; / Where first I learn'd from whence my blessings came / And lisp'd, in faltering tones, a mother's name; / That cheris'd home, where memory fondly clings, / Where eager fancy spreads her soaring wings; / Around whose scenes my thoughts delight to stray. / And pass the hours in pleasing dreams away. / Oh! shall I ne'er behold thy waves again, / My native lake, my beautiful Champlain? / Shall I no more above the ripples bend / In sweet communion with my childhood's friend? / Shall I no more behold the rolling wave, / The patriot's cradle and the warrior's grave? / Thy banks, illuminated by the sun's last glow, / Thine islets mirror'd in the waves below? / Back, back, thou present—robed in shadows lie! / And rise the past before my raptured eye! / Fancy shall gild the frowning lapse between, / And memory's hand shall paint the glowing scene; / and I shall view my much-loved home again, / My native village and my sweet Champlain."

Lake Champlain., Mouth of Saranac River.

The Saranac River stretches 81 miles across northern New York, eventually emptying into Lake Champlain near the MacDonough Monument. Upstream from Bridge Street, the river directs water into a series of canals in an attempt to increase the power generated by the river's movements. Another dam near Catherine Street has helped fuel a flour mill, shingle factory, machine shop, paper mills, and lumber mills. Flooding along the river is a constant concern, with major damage occurring repeatedly in low-lying areas throughout Clinton and Franklin Counties. Salmon angling and boating also occur in the river. The Saranac River Trail, which starts at the Saranac Street bridge and terminates near Plattsburgh High School, allows people to enjoy the river from its banks. Eventually, the trail will be extended east to Lake Champlain and west to the town of Saranac.

Plattsburg, N.Y., Saranac River.

39 City Hall and MacDonough Memorial, Plattsburgh, N. Y. John Russell Pope, Architect.

Seen from the Saranac River, the MacDonough Monument was formally dedicated on August 18, 1926. Designed by John Russell Pope, the 135-foot obelisk made of Indiana limestone commemorates "the victory of Commodore MacDonough [in] the Battle of Plattsburgh." Perched atop the monument is a 22-foot bronze eagle; carved on each of the sides is the name of one of MacDonough's ships, the *Eagle*, *Preble*, *Ticonderoga*, and *Saratoga*.

This park, located near Cumberland Avenue and in close proximity to the mouth of the Saranac River, belonged to Smith M. Weed, who completed the formal landscaping of the park, shown here around 1895. Beyond his work as a lawyer, Weed had ties to the Chateaugay Ore and Iron Company, local newspapers, the Delaware and Hudson Railroad Company, and the state Democratic Party. (Courtesy of the Ron Venne Collection, used with the permission of his family.)

Plattsburg N.Y. from Weed's Park.

Looking from Smith Weed's park toward the Saranac River, this image shows the city of Plattsburgh in the near distance. This postcard dates from before 1926, since the MacDonough Monument is not visible. In 1932, the *Plattsburgh Daily Press* bemoaned the decline of the park: "What was once known as Weed's Park has been allowed to run somewhat wild, but is still a scene of great beauty."

View of Plattsburg, N. Y. from Lake Champlain. "Sunset in Winter".

Taken from the Saranac River, this image shows Plattsburgh as it was at the turn of the 20th century. In the distance are the spires of several city churches, as well as factory buildings and other downtown businesses. The winter ice has formed over the river, allowing residents to harvest ice, go ice fishing or ice skating, and use the ice as a means of transportation.

CHAMPLAIN STATUE ON LAKE CHAMPLAIN, FROM PLATTSBURG

Champlain Monument, Plattsburg, N. Y.

During the tercentenary celebration of Samuel de Champlain's arrival on the lake, this statue was erected and dedicated. Hugh McLellan, a local man who studied at Columbia University's School of Architecture and the École des Beaux Arts in Paris, designed the statue. Made of pink granite, McLellan's monument consists of a statue of Champlain standing on top of a pedestal and a terrace. The monument is 34 feet tall and rises 61.5 feet above lake level. A Native American warrior kneels at the bottom of the statue, under the words "Champlain, 1567–1635, Navigator, Discoverer, Colonizer." The ends of a canoe emerge from two sides of the monument, commemorating the way that Champlain traveled throughout the northeastern United States and Canada.

Plattsburg, N.Y., Dock and Coal Yard.

In 1987, the Plattsburgh Harbor Marina, formerly known as the Dock and Coal Marina, announced plans for major renovations. Included in the anticipated changes were the construction of a new dock system to handle 189 boats and shoreline protection to eliminate flooding problems during high water. American Marinas Inc. purchased the marina in 1986. The Dock and Coal Company had served not only as a marina, but also as a merchant, selling coal—which they advertised as being "Always on tap. There is no waiting for the tank to heat if you use D&H Anthracite for heating water, and the fuel bills are MUCH LOWER."—as well as seeds, feeds, and paints, many of which burned in a 1938 fire. (Below, courtesy of Elizabeth Botten.)

Wilcox Wharf, Plattsburg, N.Y.

The Wilcox Wharf, more commonly referred to as the Wilcox Dock, is located off Cumberland Avenue in the city of Plattsburgh. A favorite mooring place for pleasure craft in years past, the dock was the site of arrests during Prohibition, including a 1922 haul of 72 cases of Canadian beer. A pumping station for the sewage disposal plant, a 1938 construction, is also located near the dock. In 1994, Mitch Rosenquist reported that "the sluggish economy, environmental problems and private owners stand in the way of additional projects" proposed by the City of Plattsburgh and New York State Department of Environmental Conservation. After years of struggling to clean the site, the Wilcox Dock reopened in 2007 and the Wilcox Dock Pavilion, situated between the dock and the City of Plattsburgh Healthy Lungs Trail, was dedicated in July 2012.

BEACH, PLATTSBURG, N. Y.

According to the Witherill Hotel, the Plattsburgh City Beach is the "finest freshwater beach in America, affording magnificent views of Lake Champlain, the Adirondacks and Green Mountains." The city beach lies at the entrance of Cumberland Head, next to the Cumberland Bay State Park. The Crete Memorial Civic Center, named for brothers Alfred and Wilfred Crete, who helped to fund the venture, sits between the beach and the Commodore Thomas MacDonough Highway and offers a variety of entertainments including boat and recreational vehicle shows, circus performances, and private parties. During the late 20th century, a miniature golf course sat between the Crete and the beach, offering another possibility for summer fun. Many other beaches line Clinton County's lakeshores and riverfronts. Among the most popular, after the Cumberland Head beach, are the state parks at Au Sable Point and Point au Roche, which—like Cumberland Bay—offer camping sites as well; some of these locations also offer boat launches and marinas that allow additional water activities. (Courtesy of Gary Wells.)

Regular ferry crossings from Cumberland Head to Vermont began in 1790, with less regular crossings from Chazy Landing to Isle La Motte beginning at the same time. By 1905, with the opening of the Chazy Landing Auto Ferry, that northern crossing was more regular. There, William Sweet designed and operated Lake Champlain's first gas powered ferry *The Twins*, named for his sons. After that ferry service ended in 1937, travelers had to wait for the ice to form to walk or ride across the lake, travel to a bridge, cross by personal watercraft, or drive to Cumberland Head, where the Lake Transportation Company continued to operate. Until 1976–1977, all local ferry crossings were seasonal. The Lake Champlain Transportation Company now boasts three routes: the Grand Isle, Vermont to Plattsburgh (actually Cumberland Head), New York crossing, which takes 14 minutes and for which service is provided 24 hours a day, 365 days a year; the Burlington, Vermont to Port Kent, New York crossing, which takes one hour; and the Charlotte, Vermont to Essex, New York crossing, which takes 25 minutes. (Courtesy of Gary Wells.)

Lake Champlain., Cumberland Head Light House.

Peter Comstock, who built the first structure at Split Rock, built the Cumberland Head Lighthouse in 1838 for $3,325. The conical lighthouse, made of native rubble limestone, was installed on an almost four-acre plot of land that Luther Hager sold to the federal government for $398.20. After the lighthouse was deactivated in 1934, the land was sold. However, in March 2003, the current owners, in concert with the US Coast Guard, returned the light to the tower. Both William Taberrah, a Civil War veteran, and his wife Emma served as keepers of the light. With her daughters' assistance, Emma ran the lighthouse from her husband's death in 1904 until 1919. This historic structure was commemorated during the town of Plattsburgh's bicentennial anniversary in 1985 as the central figure on the town's flag, the town's seal, and a celebratory medallion. Later, in 1991, the Plattsburgh Stamp Club also commemorated the structure, offering a special cancellation at its annual stamp show. (Courtesy of the Cole Collection, Plattsburgh Public Library.)

Ice Boating on Lake Champlain at Plattsburg, N.Y.

Designed like sailboats, ice boats ride over the ice on skis, also known as runners or skates. While not common, ice boating has occurred on Lake Champlain. In 1899, the *Plattsburgh Daily Press* asked, "Ice boating again? Well, I guess so. It's an ill wind that blows nobody good and if the March winds do play havoc with your hats and curls, they make ice boating exciting." (Courtesy of the Cole Collection, Plattsburgh Public Library.)

Simply labeled "Riverview #1 on Mooers Camp Ground," this postcard could show virtually any waterside campsite in Clinton County. It likely commemorates a stay at the Mooers Camp Meeting Association, organized in 1903, and occupying a 50-acre site on the Great Chazy River, midway between Mooers and Mooers Forks. The camp, which still exists, first used tents and later constructed a tabernacle on the site. (Courtesy of Bob Cheeseman.)

View on Shore of Lake Champlain, Cumberland Head, N. Y.

During the early part of the 20th century, Cumberland Head was an agricultural area, mixing farm life with proximity to the water. Early farm families on Cumberland Head included the Allens, Lobdells, Kollingers, Bristols, McMasters, Lavignes, Rocks, Hagars, Taberahs, Turners, MacDonoughs, McGregors, Trudeaus, Calkins, Barbers, Martins, Fiskes, and Stracks.

Chazy River Bridge, Mooers N. Y.

Bridges like the Chazy River Bridge in Mooers once had to be tended to allow boats to travel through. Robert N. Palmer described that process, referring to a bridge over the Big Chazy River in Coopersville: "While [at Fred Moore's store], I often went out to the bridge—the river was navigable then—and watched the bridge tender turn the bridge with a very large wrench. He had to open the bridge whenever a sailboat came up or down the river. He fitted the wrench, which was about four or five feet long, to a big nut in the floor of the bridge and walked around in a circle, pushing on the wrench until the bridge was pointing up and down the center of the river. After the boat had gone through, he went around in the opposite direction to close the bridge. As there were only horse-drawn vehicles at that time, there were no gates to come down or to be raised when the bridge was open."

Situated in the valley between Lyon Mountain and Ellenburg, Chazy Lake is quite popular. With a maximum depth of 72 feet, the lake is about one-and-a-half miles wide and three-and-a-half miles long. Many of the people who visit Chazy Lake do so because of its rich fishing possibilities: the lake contains lake trout, landlocked salmon, rainbow trout, smallmouth bass, northern pike, brown bullhead, yellow perch, rainbow smelt, and pumpinkseed. While noted for the pleasures of summer in a lake-side camp, Chazy Lake was also the site of a June 4, 1927, tragedy. Five Dannemora High School students—Bernadette Drolette and Kathleen Smart, seniors, and Katherine Canning, Edmund Rowan, and Thomas Tobin, juniors—drowned when their boat was overturned. The teacher who was in the boat with them survived by clinging to the side of the boat for many hours before being rescued. As a result of the accident, commencement exercises at the high school were cancelled, with the money usually spent on graduation being spent on flowers for the families of the deceased students.

Harvesting Ice on Lake Champlain, Plattsburg, N.Y.

Lake Champlain's waters offer a host of possibilities for Clinton County residents. During the 19th and early 20th centuries, one of those possibilities was harvesting ice. Many companies, including Buskey and Sons and F.Z. Jabaut, worked the ice, an arduous job that involved marking out a pond, cutting cakes of ice with large-tooth saws, using poles and tongs to pull cubes out of the water, dragging the cubes on skids to the horses or truck, and then stacking the cubes, layered and packed with sawdust. Given the labor-intensive nature of the work, it is impressive to note that Buskey and Jabaut, Plattsburgh's two top producers, each processed 6,000 tons of ice in 1902. At the height of the ice harvest, Jabaut cut 15,000 tons a year, which is equivalent to 50 freight cars a day. While these statistics discuss ice production within the city of Plattsburgh, they do not indicate the prevalence of the ice harvest in Clinton County. In fact, people up and down the lake participated, especially during years when bigger cities feared an ice shortage. (Courtesy of the Cole Collection, Plattsburgh Public Library and Dick Lynch.)

In 1608, Samuel de Champlain arrived in what is now Quebec aboard the *Don de Dieu*, or "Gift of God." One of three ships that set sail with Champlain's party, a replica (shown here) was created for the tercentenary celebration of Champlain's explorations. A 1909 *Plattsburgh Sentinel* article proclaimed, "The Don de Dieu is on the way. Sailed from Quebec Wednesday to take part in celebration here . . . The Don de Dieu, the quaint little replica of Samuel De Champlain's vessel, which was one of the features of the Quebec Tercentenary, left Quebec Wednesday morning en route for this city, where it will take part in the Lake Champlain Tercentenary celebration. Mr. Gravel and his son and cousin were on board the vessel. The Don de Dieu will be captained by Mr. Gagnon, of St. Remauld, with a crew of eight men." In 1977, Rouses Point historian John Ross recalled the ship's arrival, saying, "She was manned by a crew resplendent in the costumes of 1609 and attracted great attention at every lake port she visited." (Courtesy of the Clinton County Historian's Office.)

The Point au Roche lighthouse, shown here along with United States and Canada boundary stone and Fort Montgomery, was built in 1858. The blue limestone tower, with its wooden Cape Cod cottage, was in continuous service for 131 years, until it was deactivated in 1989. A nearby state park is home to 800 acres of "pristine woodlands, rolling meadows, stunning lake front, and scenic walking trails," according to The Friends of the Point au Roche State Park. A nature center, staffed and open to the public year round, offers various programs, while "the park's trails, including nature, hiking and biking trails, wind through interesting habitats, from forest to marsh to shoreline." In response to threats of state budget cuts and closures, the Friends of Point au Roche State Park, a not-for-profit group, was formed to "protect, preserve, and promote Point au Roche State Park." The friends describe a park whose history extends back to the Native Americans who hunted and fished here, but also includes later recreational camps like Camp Theodore Roosevelt, Camp Red Wing, and Camp Red Cloud.

The Moat, Fort Montgomery, Rouses Point, N. Y.

Built between 1844 and 1872 on the site of an unnamed Canadian fort claimed through a treaty, Fort Montgomery sports a limestone exterior and a brick structure. Named for the American Revolution general Richard Montgomery, the fort is surrounded by a moat that is 500 feet long and 37 to 50 feet wide. At the entrance, the moat is 44 feet wide and traversed by a 20-foot-by-9-foot drawbridge made of pine and oak. The moat and bridge were designed to forestall infantry attack. Now the fort welcomes visitors to the United States from Canada and to New York from Vermont.

Fort Montgomery, Rouses Point, N.Y.

BIBLIOGRAPHY

Allan, Helen et al. *Clinton County: A Pictorial History.* Norfolk; Virginia Beach: The Donning Company, 1988.

Barcomb, Peg. *Rouses Point.* Rouses Point: Village of Rouses Point, 1977.

Bombard, Judy et al. *Ellenburg Yesterday and Today.* Charlotte, NC: Delmar Printing & Publishing, 1990.

Doh, Herman. *Bluff Point Golf and Country Club 1890-1990.* Norfolk; Virginia Beach: The Donning Company, 1990.

Everest, Allan S. *Briefly Told: Plattsburgh, New York, 1784-1984.* Plattsburgh, NY: Clinton County Historical Association, 1984.

Frost, Richard B. *Plattsburgh, New York: A City's First Century.* Norfolk; Virginia Beach: The Donning Company, 2002.

Hurd, Duane Hamilton. *History of Clinton & Franklin Counties, New York.* Reprint. Plattsburgh, NY: County American Revolution Bicentennial Commission, 1978.

Old Keeseville Tales. Port Henry, NY: Essex County Publication Company.

Ritarose, David. *Historical Review of the Town of Mooers.* Mooers, NY: Town of Mooers, 1999.

Skopp, Douglas R. *Bright With Promise: From the Normal and Training School to SUNY Plattsburgh, 1889–1989, A Pictorial History.* Norfolk; Virginia Beach: The Donning Company, 1989.

Sullivan, Nell Jane Barnett and David Kendall Martin. *A History of the Town of Chazy, Clinton County, New York.* Burlington, VT: George Little Press, 1994.

Sunderland, Lincoln. *History of Peru, New York.* Second Edition. Peru: Town of Peru Bicentennial Commission, 2003.

Taylor, Sister Mary Christine. *A History of Catholicism in the North Country.* Camden, NY: A.M. Farnsworth Sons, 1972.

Winans, Maggie, ed. *Clinton County: I Remember When.* Elizabethtown, NY: Denton Publications; Senior Citizens Council of Clinton County, 1983.

Index

Adirondacks, 7, 9, 21, 25, 77, 115
Altona, 7, 44
Au Sable, 7, 8, 26, 28, 31, 32, 104, 115
Beekmantown, 7, 73
Black Brook, 7, 28,
Bluff Point, 22, 65, 102, 103, 106,
Cadyville, 35
Canada, 7, 10, 14, 17, 25, 48, 50, 70, 90, 94, 95, 101, 112, 123, 124, 125
Champlain, 7, 11, 42, 47, 48, 50, 73, 94, 95
Chazy, 7, 11, 12, 13, 44, 46, 50, 51, 73, 92, 116
Chazy Lake, 121
Cliff Haven, back cover, 99, 100, 101
Clinton, 7
Coopersville, 11, 47, 120
Cumberland Head, 15, 115, 116, 117, 119
Dannemora, 7, 25, 33, 34, 36, 37, 38, 39, 44, 91, 121
Ellenburg, 7, 41, 43, 44, 91, 119, 121
Harkness, 32
Keeseville, 7, 25, 29, 32, 104
Lyon Mountain, 8, 40, 121
Mooers, 7, 11, 42, 43, 95, 118, 120
Morrisonville, 34, 35, 36, 56. 90
Peru, 7, 22, 24, 30, 31, 32, 85
Plattsburgh, front cover, 7, 8, 15, 16, 17, 18, 20, 21, 22, 24, 25, 31, 35, 39, 44, 47, 53-70, 71-84, 85, 87, 89, 96, 98, 100, 103, 109, 111, 113, 114, 115, 116, 117, 122
Point au Roche, 14, 115, 124
Redford, 33, 34
Rouses Point, 7, 8, 9, 10, 11, 47, 49, 50, 93, 94, 123, 125
Saranac, 7, 34, 35, 36, 39, 109

Schuyler Falls, 7, 34, 35, 36, 78, 107
Sciota, 11
Valcour, 7, 19, 24, 71, 103, 105, 106
Vermont, 7, 17, 50, 70, 93, 101, 116, 125
West Chazy, 45, 46

DISCOVER THOUSANDS OF LOCAL HISTORY BOOKS
FEATURING MILLIONS OF VINTAGE IMAGES

Arcadia Publishing, the leading local history publisher in the United States, is committed to making history accessible and meaningful through publishing books that celebrate and preserve the heritage of America's people and places.

Find more books like this at
www.arcadiapublishing.com

Search for your hometown history, your old stomping grounds, and even your favorite sports team.

Consistent with our mission to preserve history on a local level, this book was printed in South Carolina on American-made paper and manufactured entirely in the United States. Products carrying the accredited Forest Stewardship Council (FSC) label are printed on 100 percent FSC-certified paper.

MADE IN THE USA